FOR DIGITAL AND FILM PHOTOG

The Best of

FAMILY PORTRAIT PHOTOGRAPHY

BILL HURTER

Amherst Media, Inc. ■ Buffalo, NY

Copyright © 2006 by Bill Hurter.
All rights reserved.

Front cover photograph by Tibor Imley.
Back cover photograph by Judy Host.

Published by:
Amherst Media, Inc.
P.O. Box 586
Buffalo, N.Y. 14226
Fax: 716-874-4508
www.AmherstMedia.com

Publisher: Craig Alesse
Senior Editor/Production Manager: Michelle Perkins
Assistant Editor: Barbara A. Lynch-Johnt

ISBN: 1-58428-172-3
Library of Congress Card Catalog Number: 200926586

Printed in Korea.
10 9 8 7 6 5 4 3 2 1

Table of Contents

Why do people have a family portrait made? Taken every few years, the family portrait provides cherished memories of how the family looked "back then" and a fond record of the children's growth. Family portraits also document the growth of a family, as new generations are added to the group. Master photographer Robert Love says, "In our area, the number one reason that clients call us to create a family portrait is because the complete family is getting together for some special occasion. Usually the parents have one or more grown children who don't live at home anymore. More often than not, this

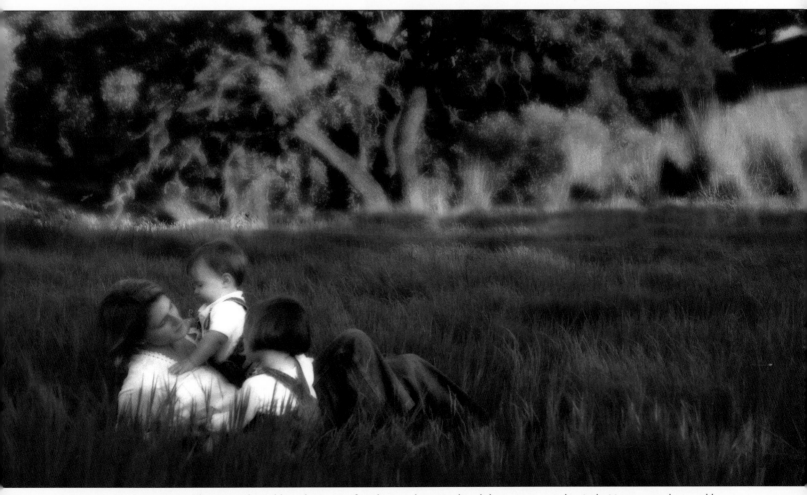

A great portrait captures the warmth and love between family members. In this delicate portrait by Judy Host, a mother and her two children enjoy the cool shade of a summer afternoon. Judy enhanced the image with diffusion and grain effects produced in Photoshop to lend an emotional veil to the image. The photo was made with Kodak DCS Pro 14n and 50mm lens.

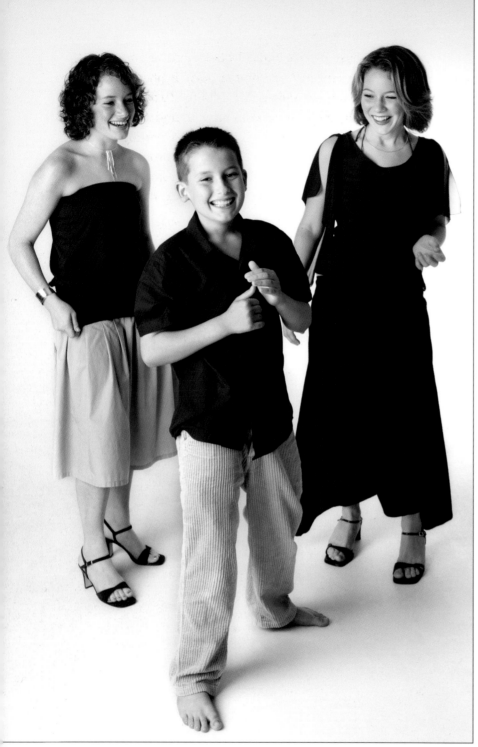

The modern-day family portrait should be a fun experience for the family members. Almost gone are the days of rigid posing, replaced by less formal more emotional imagery. Photograph by Marcus Bell.

ably—mother and father together, all the children together, mother and daughters, father and sons, mother with all the children, all the men or women in the family, and so forth.

Photographing families is a challenge that will draw on all of your photographic skills, since the family portrait *as a whole* is only as good as each of the *individuals* in the portrait. You should be able to look at each person in the portrait and ask, "Could each of these individual portraits stand alone?" If the answer is "Yes," then the photographer has done a good job. According to Monte Zucker, "The first thing to remember is that each person in the group is interested primarily in how he or she looks. So, that means that you have to pay attention to every person in the group, individually. No matter how good the pattern of the group, if people don't like the way they look, all your time and effort are wasted." Robert Love concurs. "Each person in a group must look great—as if they were photographed alone," he says. Love makes it a point, in fact, to pose and light great individual portraits within his groups, a technique that takes time and patience to perfect.

Family portraits have changed over the years. With so many extended families, due to remarriage, the family portrait often doesn't resemble the family portrait of years past. Not only has the structure of the family changed, but so has the attitude of what constitutes a family portrait. A mother and her kids, two young sisters, a dad and his newborn son, even a man and his dog all constitute the modern-day family portrait. The primary connection in any family portrait is the love shared between the subjects. There is a bond that is deeper than association or friendship, and it is the task of the family portrait photographer to render that connection with emotion and honesty. That is what makes a great family portrait.

person is married and has a family, as well. This gives us an opportunity to create a three-generation memento. With these extended families, we have photographed from eight to thirty people in one image." Having the family all in one place also gives you the opportunity to photograph a number of secondary family portraits, which will increase sales consider-

○ ABOUT THIS BOOK

It is my hope that you will not only learn the technical side of family portraiture from this book—how to pose, light, and photograph family groups on a higher plane—but that you will also become a fan of the design systems used in creating compelling group portraits. This is the path to a higher level of photography and self-expression.

To illustrate this book, I have called upon some of the finest and most decorated portrait photographers in the country. Some, like Monte Zucker and Bill McIntosh, are living legends among modern-day photographers. Most are not only gifted photographers but teachers as well, who lecture throughout the United States. Some of the featured photographers are newcomers to the limelight. In all cases, though, their

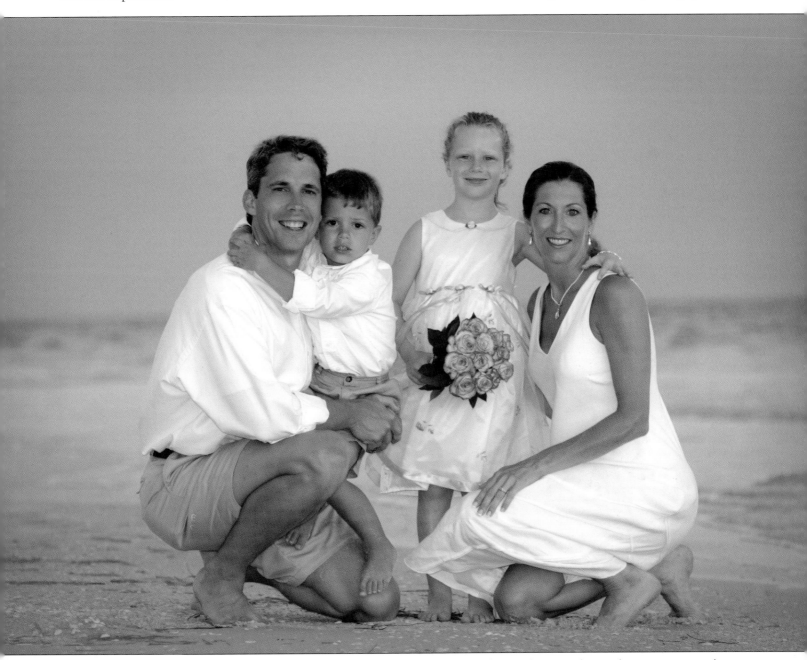

When the entire family is pictured, a more formal pose is often called for. Here Tibor Imely created a timeless composition that features the mom and dad as bookends in the composition. A popular feature of family portraits is detailed coordination of clothing tones within the photo. A trademark of Imely's seems to be khaki and white. The light is twilight with a blink from a Sunpak 120 barebulb flash, two stops less intense than the daylight reading. Image was made with a Canon EOS-1D Mark II and a zoom lens at the 150mm setting.

Marcus Bell photographs families, weddings and landscapes with equal skill and one of his trademarks is to never settle for the cliché, always trying to reinvent the moment. He has done so here in a humorously affectionate portrait of father and son made in his studio.

photography is exemplary. Many of the photographers included in this book have also been honored by the country's top professional organizations, the Professional Photographers of America (PPA) and Wedding and Portrait Photographers International (WPPI).

I would especially like to thank the following photographers for their technical assistance and boundless expertise: Robert Love, Bill McIntosh, Norman Phillips, and Monte Zucker.

Family has always been an important part of contemporary life, but since the 9/11 tragedy it has become increasingly vital. Today, images of family are even more highly regarded and the business of producing memorable family photographs has never been more sought after. It is my hope that this book will provide a solid reference to developing such a business.

1. Qualities of a Good Family Portrait

A portrait is not a snapshot. What distinguishes it is the photographer's sensitivity toward the subject. A good family portrait conveys information about the uniqueness of both the family and the individuals in the family. Through controlled lighting, posing, and composition, the photographer tries to capture the essence of the subjects, at once recording the personalities and the pleasing likenesses of the family.

○ **FLATTERS THE SUBJECT**

A good family portrait is one that flatters each of the subjects and is pleasing to the eye. With a working

Notice the simplicity of the elegant gray loveseat and matching painted canvas background. A single softbox lights the entire group with multiple soft hair lights illuminating the family's hair and shoulders. Note, too, that photographer Frank Frost decided on no shoes. It's not only a casual pose, but shoes, more than any article of clothing, date a portrait.

ABOVE—A good portrait of a family will show everyone looking good, with pleasant, natural expressions in a beautiful environment. Here, Tibor Imely created a lovely family portrait at sunset. The twilight was coming into the scene from camera right and the shadows were filled with a Sunpak 120 barebulb flash set at two stops under the ambient reading. The flash was positioned on the same side of the camera as the twilight. The image was made with a Canon EOS-1D Mark II camera and 180mm lens; the exposure was $\frac{1}{125}$ second at f/4.4. Tibor added a slight vignette around the image in Photoshop to focus attention on the group. **FACING PAGE**—Invariably, family sittings involve individual portraits of the children. Stacy Bratton, an expert at children's portraiture, can coax the most endearing expressions from her little subjects. She uses a Chimera Soft Pro softbox, which measures 72 x 54 inches, with an extra white baffle in the middle, straight on to the subject. This accounts for the square catchlights. She uses a white drop ceiling above the set and bounces light into the white flat for fill light and hair light, and to evenly light her backgrounds.

knowledge of basic portrait techniques, a sense of design, and good rapport with your subjects, you can create an image that is both pleasing and salable—and one that each person in the family will cherish. Monte Zucker, who is recognized as one of the finest portrait photographers in the world, says, "A Monte Portrait is simple, elegant, void of distractions, and usually flatters the subjects. It makes a statement mostly about the subjects, but at the same time includes my interpretation of that person."

○ A COORDINATED LOOK

Unlike a fine portrait of an individual, a family group portrait also conveys a sense of importance and character about the group. It has a prearranged sense of design and arrangement of its elements, a uniformity of expression and, in many instances, a coordination of color and clothing. These aspects, of course, are in addition to controlled lighting, posing, and composition. So as you may be beginning to see, a fine family portrait is not an easy picture to produce.

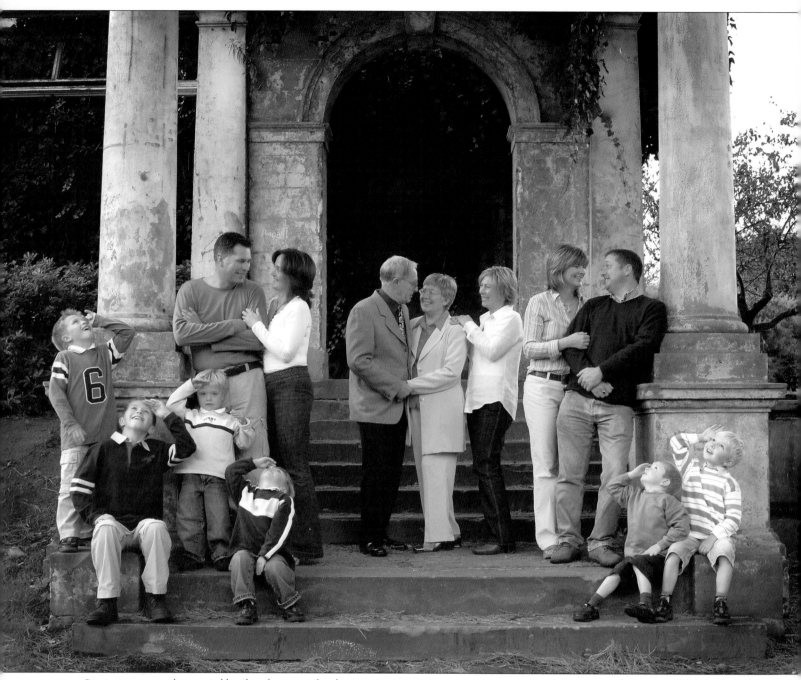

Portraits are made special by the photographer harnessing a spontaneous moment or suggesting something special. Here, David Worthington had the adults look at each other with genuine affection. He had the kids pretend they were trying to overhear the adults' conversation. The kids on the right seem to have understood the concept; those on the left are sort of saluting to no one in particular, which lends a certain charm and foolishness to the portrait. David used a Fuji FinePix S2 Pro and 24mm lens to make the image, which was exposed at 1/45 second at f/5.6 at ISO 200.

○ THE ARTIST'S VISION

The great portrait artist is one who sees things others don't. This can obviously be said of any artist, visual or otherwise, but the portrait artist has to appraise and apprise in a manner of seconds, plotting a visual course that will reveal what he or she has seen and wants to reveal. A great portrait photographer sees many aspects of a person in a split-second. Tim Kelly, a modern day master, says, "Watch your subjects before you capture the image. Sometimes the things they do naturally become great artistic poses." For this reason, Kelly does not warn his clients when he is ready to start a portrait session. "I don't believe in faking the spontaneity of the subject's expression," he says.

○ RAPPORT WITH SUBJECTS

An accomplished portrait photographer is also able to make a positive connection with the people in front of the camera, time after time. The cliché of being a "people person" rings true here—but more than that, the portrait photographer is able to connect with people in such a way that, when their portrait is made, there is a communication that occurs beyond and without words. Perhaps it's no more than empathy, but beneath that the photographer must have a strong desire to bring the best out of his or her subjects—to make them look their finest and to bring out the best in them emotionally.

Photographers like Bill McIntosh, an expert portrait photographer for more than 50 years, sees one of the keys to his success as his ability to enliven his subjects, developing an endearing kind of rapport. His tools of the trade are, in his words, "outrageous flattery and corn-ball humor." He rarely stops talking and the subject is part of the reverie and good time.

○ REMEMBERING

On another of its most basic levels, the family portrait is a means of remembering ("This is how our sister looked when she was 11—she still has that impish grin 50 years later!"). This function of the portrait, while on the surface mundane, is no less important than the view of the portrait as psychological profile, historical tapestry, or any other of its popular definitions.

○ CHARACTER AND EMOTION

Monte Zucker, who has always been ahead of the curve in predicting what the public wants, recognizes the importance of emotion. "I want the viewer to *feel* a Monte Portrait as well as *see* it," he says. "If you are emotionally connected with my subjects when you see their portraits, I feel that I have done my job." Like the wedding photojournalist, who brings out the hidden emotions of the wedding day, the contemporary portrait photographer must also seek out hidden emotions. A good portrait can't just be about classical composition, perfect posing, or rich colors, it must be an effective glimpse into the soul. This is one of the things that separates a great portrait from a "mere likeness"—even a flattering one.

While it is impossible to obtain a clear understanding of a person's complex character from a single stolen moment in time, it is possible to convey something of a person's character, as well as their attitudes and something about their "station in life."

○ A TIME CAPSULE

Others see the portrait, especially the family portrait, as a story-telling device—a time capsule, holding treasured totems of a time that will someday be lost. These include both the people and, if the portrait is created in the family home, a place and way of life.

Portraits taken in the home define not only an environment, but also the history of the family members recorded there. It is important that detail be vivid in home sittings, as these are the things that will be treasured for years to come. If the photographer combines the historical aspects of home with an emotional rendering, then he or she will have created a portrait of great lasting value.

Denver portrait artist Deanna Urs lives for the details. She says, "First, I examine the architecture of the family home. I look for artistic elements, like the lines and shapes of doorways, arches, and pillars." At this time she learns the family's taste and style. Deanna says, "Find out what style your guest (Urs calls her clients "guests") will enjoy, because the image you will create for them is not just for now; it is forever."

She continues, "Secondly, I study the points of special interest, like heirloom furniture pieces or works of art that are significant to the family." Urs will find something that is special to the family, something that reflects who they are—an Oriental rug or silk drapes, for example—and then use these items as a background or prop in the photograph.

Deanna takes this a step further. She might find two things of great value to the family and combine them, even if, logically, they would normally be separate. An example is a treasured sofa that she positioned outdoors by a family's crested gate—two group-defining items in one locale. This juxtaposition between exterior and interior it is what happens when, as Deanna says, you "dare to play with no fear." Families will generally join in the spirit of fun and playfulness, making the experience somewhat like a treasure hunt.

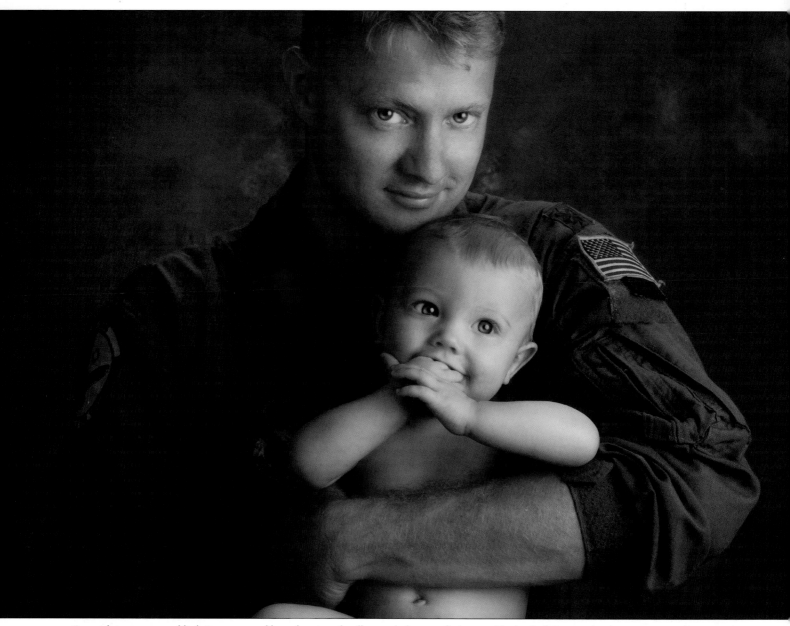

Smooth wraparound lighting, created by a large umbrella used close to father and baby, helps to make this a very tender portrait. Their eyes are so similar to each other—with a hint of gentleness and joyfulness—that it becomes a very special portrait. Photograph by Frank Frost.

○ THE EXPRESSION

Expression is all-important in the fine portrait. While a gifted photographer is capable of producing literally dozens of saleable portraits in a single sitting, there is always one portrait that stands above the rest, and its high caliber is usually related to the expression. Many great portrait photographers believe the expression must be "tranquil," so as to provide a glimpse into the subjects' character. The expression should also be compelling, causing the viewer to gaze into the eyes of the portrait, appreciating the uniqueness of each person in the image.

Often, the compelling nature of a portrait is related to the gaze of the subject, who may often be "looking into the camera" but, by extension, looking out at the viewer as if inviting inquiry and understanding. All clichés aside, the eyes are the most interesting and alluring part of the human face, allowing the viewer to become totally absorbed in the portrait.

aturally, none of the more ephemeral qualities of the fine family portrait matter if the image contains technical flaws that reduce its appeal. From selecting the right lens to focusing, maximizing the depth of field, and metering, family portraits present numerous technical challenges that must be addressed by the successful photographer.

If you're a digital photographer, be sure also to review chapter 3 for technical information geared toward this technology.

○ LENS SELECTION

Normal Lens. Using a "normal" focal length lens (50mm in 35mm format, 75–90mm in the medium

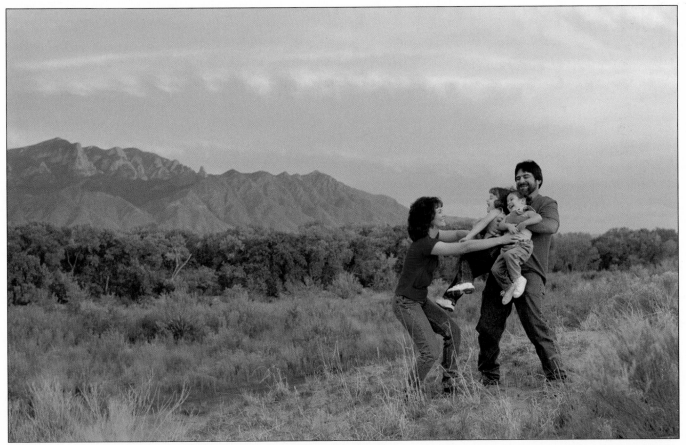

A wide-angle lens will stretch out the foreground and "place" the subjects in an environment, such as was done here by Frank Frost. The wide-angle sets the scene in the New Mexico mountains, with their abundance of golden hues. Frank positioned the family off center in the frame to provide a visual balance with the distant mountain range. He exposed the image at twilight with no flash. The casual color coordination and playfulness of the image make it a memorable family portrait.

may encounter is that, even at wide lens apertures, it may be difficult to separate the subject from background. This is particularly true when working outdoors, where patches of sunlight or other distracting background elements can easily detract from the subjects. In the age of Adobe Photoshop, however, such problems are easily handled by selectively blurring or altering the tone of the background elements.

Short Telephotos. All types of portraiture demand that you use a longer-than-normal lens, particularly for small groups. The general rule of thumb is to use a lens that is two times the diagonal of the film you are using. For instance, with the 35mm format, a 75–85mm lens is a good choice; for the 2¼-inch square format (6x6cm), 100–120mm is good; and for 2¼ x 2¾-inch cameras (6x7cm), 110–150mm is recommended. These short telephotos provide normal perspective without subject distortion. The short telephoto provides a greater working distance between camera and subjects while increasing the image size to ensure normal perspective. For group portraits, be aware, however that the subjects in the front row of a large group may appear much larger than the subjects in the back of the group if you get too close; if this is the case, consider switching to a longer lens.

Long Telephotos. Some photographers prefer the longest lens possible when shooting family groups because of the aforementioned foreshortening problem; for example, a 150mm lens on a 6x6cm camera. This keeps the people in the back of a larger group the same relative size as the people in the front of the group.

Wide-Angle Lenses. When making group portraits, you are often forced to use a wide-angle lens—it's often the only way you can fit the entire group into the shot and still maintain a decent working distance. Unfortunately, wide-angle lenses will actually distort the subjects' appearance—particularly those closest to the frame edges. Raising the camera height, thus helping to place all subjects at the same relative distance from the lens, can minimize this effect. For this reason, many expert group photographers carry a stepladder or

A short telephoto lens used close to the subject produces good perspective and a large image size. When used wide open, telephoto lenses produce very little depth of field, as you can see in this portrait by Marcus Bell. Only the eyes and lips are in focus. The rest of the image is pleasantly soft.

formats) usually requires you to move too close to the subject to attain an adequate image size, thereby altering the perspective. This proximity to the subject exaggerates subject features—noses appear elongated, chins jut out, and the backs of heads may appear smaller than normal. This phenomenon is known as foreshortening.

When making ¾- or full-length portraits, however, you are farther away from your subject than when making a closer portrait of only a few people, so the normal lens is a good choice. The only problem you

FACING PAGE—In a portrait such as this, the focusing is critical. Joseph and Louise Simone created this formal yet intimate portrait of mother and son in the studio. Even at f/32 it would have been difficult to hold both mother and son in focus. Instead, the focus was shifted so the hands and face of the boy are very sharp and the mother is a little soft. The elegant hairlights produce highlights in the mother's hair that enhance the feeling of sharpness in that plane of the photo.

16 THE BEST OF FAMILY PORTRAIT PHOTOGRAPHY

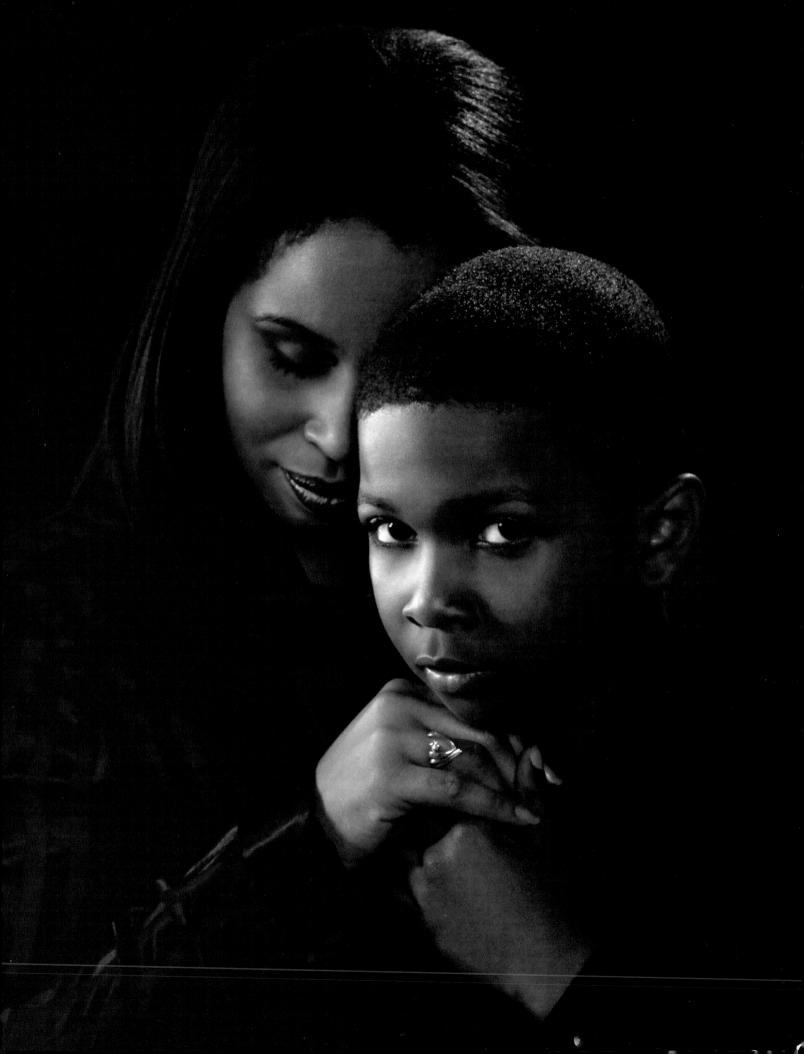

scope out the location in advance to find a higher vantagepoint. The background problems discussed above (lack of separation) can be even more pronounced with wide-angles than with normal focal-length lenses.

○ DEPTH OF FIELD

Wide-angle lenses have greater inherent depth of field than telephotos. That's the perception, anyway. The truth is that any lens, whether it's a wide-angle, normal, or telephoto, will have approximately the same depth of field if the image size is the same at the focal plane. Depth of field is determined by f-stop and image magnification. If we change lenses but don't move the camera, the depth of field will change. But if we have the same head/face size in the camera and the same f-stop, the depth of field is essentially the same.

Camera-to-Subject Distance. The closer you are to your subject, the greater the image magnification and, consequently, the less depth of field you will have, at any given aperture. When you are shooting a close-up image of faces be sure that you have enough depth of field at your working lens aperture to hold the focus on the frontal planes of all the faces.

Medium Format vs. 35mm. Another thing to remember is that medium-format lenses have less depth of field than 35mm lenses. A 50mm lens on a 35mm camera will yield more depth of field than a 75mm lens on a medium-format camera, even if the lens apertures and subject distances are the same. This is important because many photographers feel that if they go to a larger format, they will improve the quality of their portraits. This is true in that the image will appear improved simply by the increase in film size; however, focusing becomes much more critical with the larger format.

Learn to use your lens' depth-of-field scale. The viewfinder screen is often too dim when the lens is stopped down with the depth-of-field preview to accurately gauge overall image sharpness. Learn to read the scale quickly and practice measuring distances mentally. Better yet, learn the characteristics of your lenses. You should know what to expect in terms of sharpness and depth of field at your most frequently used lens apertures, which for most family portraits will be f/5.6, f/8, and f/11.

Optimum Shooting Apertures. Choosing the working lens aperture is often a function of exposure level. In other words, you often don't always have much of a choice in the aperture you select—especially when using electronic flash or when shooting outdoors.

A lens used wide open (at its maximum aperture) theoretically suffers from spherical aberration; a lens at its smallest apertures suffers from diffraction. Both of these conditions slightly reduce the overall sharpness of the recorded image. Therefore, when you have a choice, experts say to choose an aperture that is 1½ to 2 full f-stops smaller than the lens's maximum aperture. For instance, the optimum lens aperture of an f/2 lens would theoretically be around f/4.

The trend in contemporary portraiture is to use wide-open apertures with minimal depth of field. The effect is to produce a thin band of focus, usually at the plane of the eyes. One of the by-products of shooting portraits in this way is a blurred background, which can be quite appealing. This technique is not, however, very practical for family groups since you will usually require all the depth of field you can create to keep the entire group in focus.

○ FOCUSING

Generally speaking, the most difficult type of portrait to focus precisely is a close-up portrait. It is important that the eyes and frontal features of the face are tack-sharp. It is usually desirable for the ears to be sharp as well, but not always.

When working at wide lens apertures where depth of field is reduced, you must focus carefully to hold the eyes, ears, and tip of the nose in focus. This is where a good knowledge of your lenses comes in handy. Some lenses have the majority of their depth of field behind the point of focus; others have the majority of their depth of field in front of the point of focus. In most cases, the depth of field is split 50–50, half in front of and half behind the point of focus. It is important that you know how your different focal-length lenses operate. And it is important to check the depth of field with the lens stopped down to your taking aperture, using your camera's depth of field preview control (or, if shooting digitally, the camera's LCD).

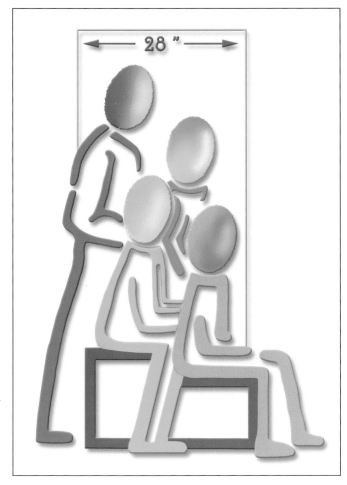

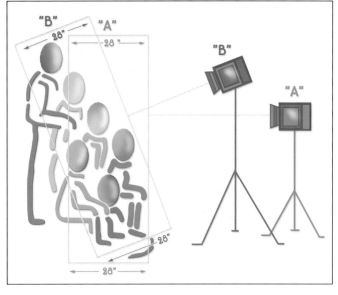

LEFT—Subjects in the back of the group can lean in and subjects at the front of the group can lean back slightly so that all of the faces fall within one plane. Diagram concept courtesy of Norman Phillips. **ABOVE**—To include additional subjects in the same amount of space, raise the camera height, angling the camera downward so that the film plane is more parallel to the plane of the group. The plane of focus is now more in harmony with the shape of the group, thus extending the useful range of focus. Diagram concept courtesy of Norman Phillips.

Focusing a ¾- or full-length portrait is a little easier because you are farther from the subject, where depth of field is greater. Again, you should split your focus, halfway between the closest and farthest points that you want sharp in the subject. This is particularly true of groups that may extend over a much wider area than portraits of individuals.

It is essential for family groups of two or more that the faces fall in or close to the same focusing plane. This is accomplished with posing and careful maneuvering of your subjects or your camera position. If one or more of the people in the group is out of focus, the portrait may be flawed, depending upon your intentions.

Shifting the Focus Point. Once you have determined the depth of field for a given lens at a given focusing distance and taking aperture (by examining the lens's depth-of-field scale), you know the range in which you can capture all of your subjects sharply. For example, at a camera-to-subject distance of 10 feet, an 80mm lens set to f/8 will, hypothetically, produce depth of field that ranges from 10 feet to 12 feet 4 inches, producing an effective depth of field of roughly 28 inches. Based on this, you'll know that you must modify the poses of each person in the group to accommodate that narrow zone of focus. As seen in the diagram above (left), one way to do this is to have the subjects in the back of the group lean in and the subjects at the front lean back slightly.

Making the Film Plane Parallel to the Group Plane. Suppose your family group is bigger than the one pictured above and you have no more room in which to make the portrait. One solution is to raise the camera height, angling the camera downward so that the film plane is more parallel to the plane of the group. You have not changed the amount of depth of field that exists at the given distance and lens aperture, but you have optimized the plane of focus to accommodate the given range (see diagram above).

Shifting the Field of Focus. Lenses will characteristically focus objects in a somewhat straight line, but not entirely straight. If you line your subjects up in a

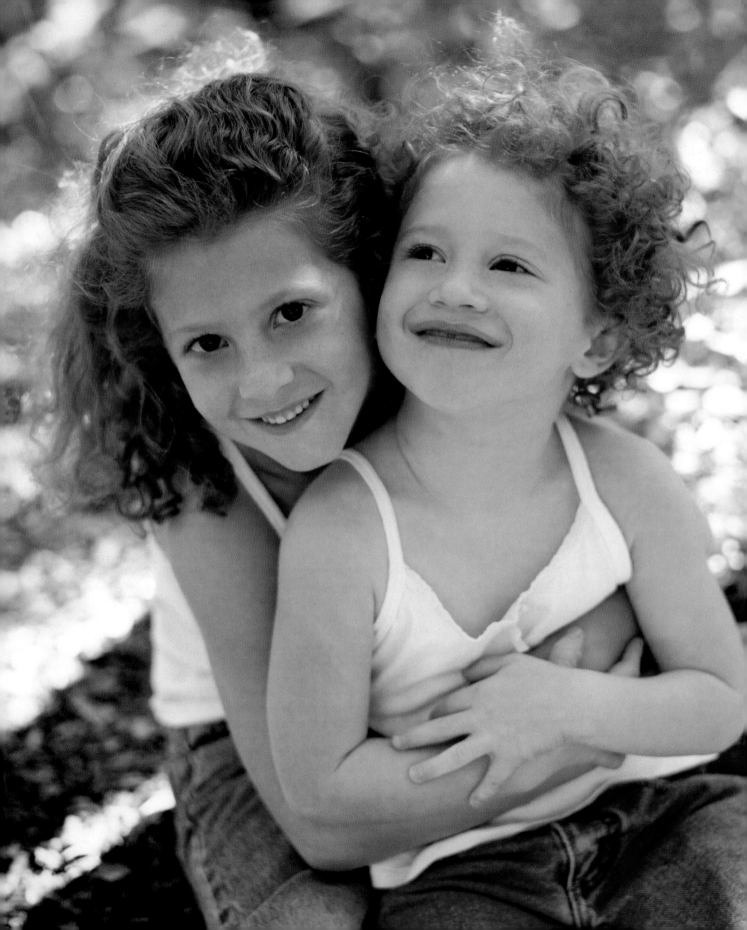

FACING PAGE—Sometimes when working in low light, it is impossible to keep all of the subject planes in focus. You don't dare sacrifice shutter speeds that are needed to freeze squirming little ones. The next best thing is to raise the camera angle to make the angle of the subject plane closer to the angle of the film plane. That is what Stacy Bratton did in this wonderful portrait. In spotty sunlight like this, one has to bias the exposures towards the shadows and let the highlights overexpose.

straight line and back up so that you are roughly 25–30 feet or more from the group, all subjects will be rendered sharply at almost any aperture. The problem is that at a distance, subjects become unrecognizable, so you must move closer, making those at the ends of the group farther away from the lens than those in the middle. As a result, those at the edges of the frame may be difficult to keep in focus. The solution, simply, is to "bow" the group, making the middle of the group step back and the ends of the group step forward so that all the members of the group are the same relative distance from the camera. To the camera, the group looks like a straight line, but you have actually distorted the plane of sharpness to accommodate the group (see the diagrams on the next page).

Autofocus Technology. Autofocus, once unreliable and unpredictable, is now thoroughly reliable and extremely advanced. Some cameras feature multiple-area autofocus so that you can, with a touch of a thumbwheel, change the active AF sensor area to different areas of the viewfinder (the center or outer quadrants). This allows you to "de-center" your images for more dynamic compositions. Once accus-

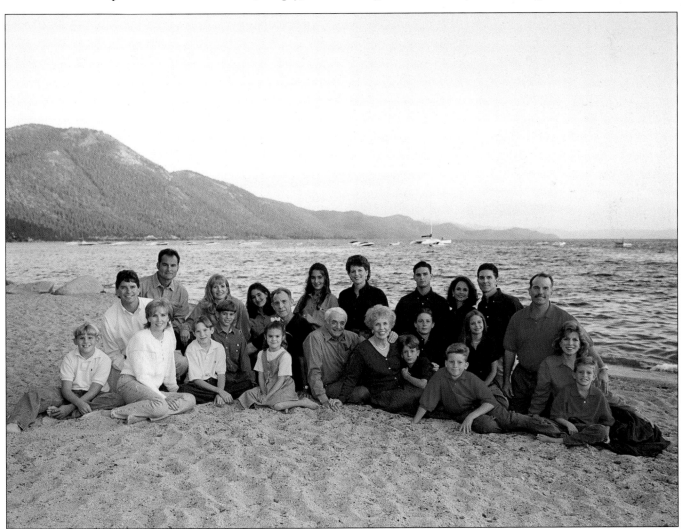

In this large group, the photographer shifted the plane of focus by moving those in the center back and those on the ends closer to form a "bow," creating the impression that all the subjects are at the same relative distance from the camera. This is a technique that helps control your plane of focus when depth of field is at a minimum. Also, note that the photographer had each subgroup dress in complementary colors, a technique that will be discussed in a later chapter. Photograph by Robert Love and Suzanne Love.

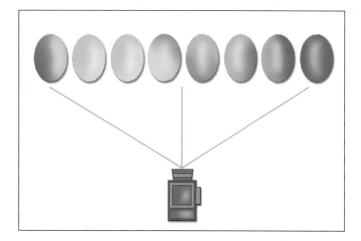

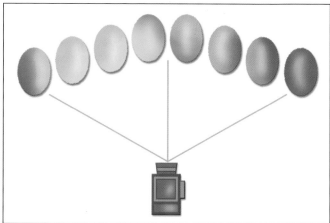

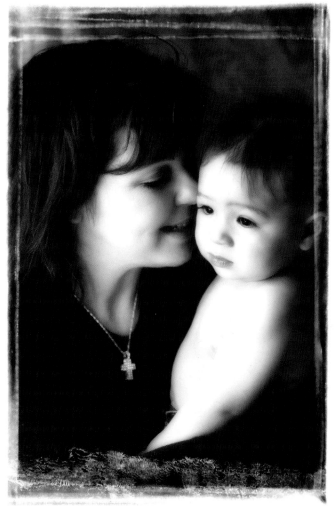

ABOVE—When a straight-line group is configured, the subjects directly in front of the lens will be closest to the camera lens. Those at the ends of the group will be a greater distance away from the lens. By "bowing" the group (the centermost people taking a step back and the outermost people taking a step forward and everyone in between adjusting), all will be equidistant from the lens and focusing will be a snap—even at wider apertures. Diagram concept courtesy of Norman Phillips. LEFT—In this portrait by Judy Host, a higher-than-normal camera position was used, but because the focal length is longer than normal (65mm) there is no subject distortion. The image was made with a Kodak DCS Pro 14n and given a border treatment in Photoshop. FACING PAGE—Timing and anticipation are the key ingredients in this great portrait of a boy and his dogs. This is a portrait that every parent would cherish. Janet Baker Richardson made it with T-Max film and a fast shutter speed to freeze the oncoming action. She made sure to hold focus on the boy moving toward her. Janet likes to find what she calls "pockets of pretty light" around clients' homes. Here, she harnessed the weak Southern California morning sunshine, which is often diffused by an overhead marine layer.

tomed to quickly changing the AF area, this becomes an extension of the photographer's technique.

Using autofocus when photographing moving subjects used to be an almost insurmountable problem. While *you* could predict the rate of movement and focus accordingly, the earliest AF systems could not. Now, however, almost all AF systems use a form of predictive autofocus, meaning that the system senses the speed and direction of the movement of the main subject and reacts by tracking it. This is an ideal feature for activity-based portraits, where the subject's movements can be highly unpredictable.

A new addition to autofocus technology is dense multi-sensor area AF, in which an array of AF sensor zones (up to 45 at this writing) are densely packed within the frame, making precision focusing much faster and more accurate. These AF zones are user selectable or can all be activated at the same time for the fastest AF operation.

○ **CAMERA HEIGHT AND PERSPECTIVE**
When photographing family groups, there are a few rules that govern camera height in relation to the subjects. These rules will produce normal perspective.

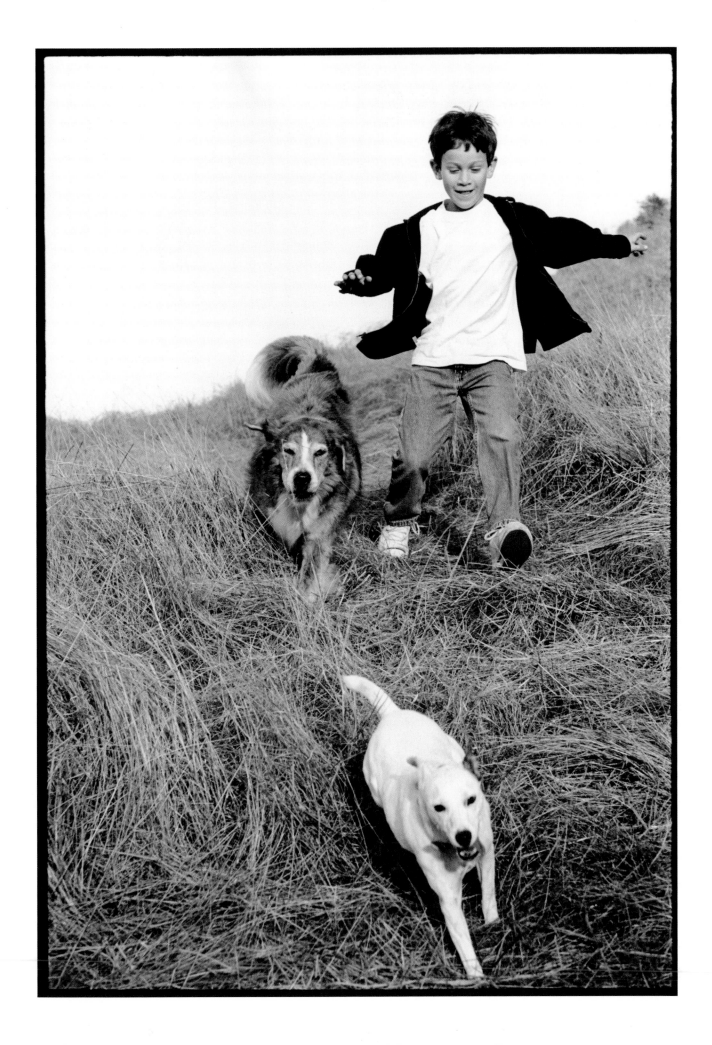

For small groups being photographed close-up, the rule of thumb is that the camera height should be parallel to the middle face in the grouping. For ¾-length portraits, the camera should be at a height approximately midway between the waists and necks of the subjects. In full-length portraits, the camera should be at around chest height of the tallest subject.

In each case, you'll notice that the camera is at a height that divides the subjects into two equal halves in the viewfinder. This is so that the features above and below the lens–subject axis are the same distance from the lens, and thus recede equally for "normal" perspective. As you will see, when the camera is raised or lowered, the perspective (the size relationship between parts of the photo) changes. Raise the camera and feet get smaller. Lower the camera and heads get smaller. By controlling perspective you will render your subjects more faithfully, without disquieting distortion.

○ SHUTTER SPEEDS

You should choose a shutter speed that stills both camera and subject movement. If you are using a tripod and shooting indoors, $\frac{1}{30}$–$\frac{1}{60}$ second should be adequate to stop average subject movement. If you are using electronic flash, you are locked into the flash-sync speed your camera calls for (unless you are "dragging" the shutter to bring up the ambient light level).

When working outdoors, you should generally choose a shutter speed faster than $\frac{1}{60}$ second, because slight breezes can cause the subjects' hair to flutter, producing motion during the moment of exposure.

If you are handholding the camera, the general rule of thumb is to use the reciprocal of the focal length lens you are using for a shutter speed. For example, if using a 100mm lens, use $\frac{1}{100}$ second (or the next highest equivalent shutter speed, like $\frac{1}{125}$) under average conditions.

If you are very close to the subjects, as you might be when making a portrait of a couple, you will need to use a faster shutter speed. When farther away from the subject, you can revert to the shutter speed that is the reciprocal of your lens's focal length. Higher image magnification means you need to use a faster shutter speed.

Image-Stabilization Lenses. One of the great technical improvements is the development of image-stabilization lenses. These lenses optomechanically correct for camera movement and allow you to shoot handheld with long lenses and relatively slow shutter speeds. Canon and Nikon, two companies that currently offer this feature in their lenses, offer a wide variety of zooms and long focal-length lenses with image stabilization. If using a zoom, for instance, which has a maximum aperture of f/4, you can still shoot handheld wide open in subdued light at $\frac{1}{10}$ or $\frac{1}{15}$ second and get dramatically sharp results. The benefit is that you can use the light longer in the day and still shoot with higher-resolution ISO 100 and 200 speed films or digital ISO settings.

Shutter Speed or Depth of Field? When shooting family groups with action, use a faster shutter speed and a wider lens aperture. It's more important to freeze subject movement than it is to have great depth of field for this kind of shot. If you have any questions as to which speed to use, always use the next fastest speed to ensure sharper images.

Bill McIntosh, a superb environmental group portrait photographer chooses shutter speeds that are impossibly long—even when using cumbersome medium format cameras. He works with strobe and often lights various parts of large rooms with multiple strobes. Some of the strobes may be way off in the distance, triggered by radio remotes synced to the shutter release. In order to balance the background strobes with the ambient light in the room and the subject light, he often has to reduce the light on the subjects to incorporate all these other elements, and consequently ends up shooting at shutter speeds as long as

FACING PAGE—Marcus Bell used the soft filtered shade of a clearing to photograph this Australian family. Australian family portraits favor spontaneity and fun rather than formal posing. Marcus, shooting at close to the lens's widest aperture, had to focus on the two children in the foreground for this portrait to be a success. Mom and Dad, and to a lesser extent the child in Dad's lap, are slightly less sharp. In such situations, you will often find you need to decide if you want to use a faster shutter speed to stop any motion of the kids or a smaller aperture (and correspondingly longer shutter speed) for improved depth of field. Here, Marcus opted for the faster shutter speed.

¼ second. For the inexperienced, shooting groups at these shutter speeds is an invitation to disaster, yet McIntosh routinely does it with incredible results.

○ FILM CHOICE

ISO. Portraits can be made on any type of film stock. However, extremely slow and extremely fast films should be avoided. Black & white and color films in the ISO 25 range tend to be slightly too contrasty for portraits, and the exposure latitude tends to be very narrow with these films; you tend to lose delicate shadow and highlight detail if exposure is even slightly off.

Faster films, particularly in black & white, provide more margin for error in the area of exposure and development, but are often too grainy to be used successfully in portraiture. The contrast of such films is often lower than may be desirable for family portraiture. However, at least in the case of fast black & white films, the contrast can be suitably altered in development or by printing the negatives onto variable-contrast enlarging papers.

Today's color films in the ISO 100–400 range have amazing grain structure that's almost non-existent. Also, their exposure latitude often ranges from 2 stops under to 3 over normal. Of course, optimum exposure is still and will always be recommended—but to say that these films are forgiving is an understatement.

Color-Negative Film. Kodak and Fujifilm, offer "families" of color negative films. Within these families are different speeds, from ISO 160 to 800, for example and either varying contrast or color saturation, but with the same color palette.

Kodak's Portra films include speeds from ISO 100 to 800 and are available in NC (natural color) or VC (vivid color) versions. Kodak even offers an ISO 100 tungsten-balanced Portra film as well as a chromogenic ISO 400 black & white Portra (which can be processed in C-41 chemistry).

Fujicolor Portrait films, available in a similar range of speeds, offer similar skin-tone rendition among the different films as well as good performance under mixed lighting conditions, because of a fourth color layer added to the emulsion.

These films are ideal for portrait photographers because different speeds and format sizes can be used in the same session with minimal differences observed in the final prints. Another advantage of these films is that they have similar printing characteristics and identical scanner settings, meaning that different speed films can be scanned at the same settings.

Exposure. As mentioned above, most current color negative films have outstanding exposure latitude. This often leads to sloppy habits, since you know that the film can *handle* the exposure errors. The best negative, always, is one that is properly exposed. It will yield rich shadow detail and delicate highlight detail and will avoid costly remakes at the lab.

Black & White Film. With black & white portraits, contrast is a more important ingredient than it is in color portraits. In color, you are locked in to the degree of contrast you can produce in the image. Color printing papers can only render so much contrast, and it cannot be significantly altered. You can alter the contrast of a black & white negative by increasing or decreasing development. (By increasing negative development, you increase contrast; decrease development and you lower contrast.)

This is important to know, because the contrast in your portraits will vary a great deal. Those shot in bright sunlight with a minimum of fill illumination, or those shot in other types of contrasty lighting, should be altered in development by decreasing development by a minimum of 10 percent. Portraits made under soft, shadowless light, such as umbrella illumination, will have lower contrast, so the development should be increased at least 10 percent—sometimes even 20 percent. The resulting negatives will be easier to print than if developed normally and will hold much greater detail in the important tonal areas of the portrait.

Exposure. In black & white, your aim is to achieve consistent fine-grained negatives with the maximum allowable highlight and shadow detail. If you find that your normally exposed negatives are consistently too contrasty, or not contrasty enough, decrease or increase development accordingly. (*Note:* decreasing development decreases contrast; increasing development time increases contrast.)

If your negatives come out consistently over- or underexposed, then you must adjust the film speed you are using to expose the film. For instance, if you use an

Robert Love photographed this lovely family portrait in late afternoon shade with a Bronica SQAi and 135mm lens. He used a Lumedyne strobe inside a 24-inch Larson Softbox fired by a Pocket Wizard radio remote. The softbox was positioned next to the camera so the light was even across the group. Metering with a handheld flash meter is essential to a scene like this. Robert metered the ambient frontal light on the faces, ignoring the backlighting coming from behind and to the sides of the family. He set the output of the strobe one stop less than the ambient light exposure so that the flash merely added catchlights to their eyes. The effect is subtle but effective.

intermediate-speed film—ISO 100 or 125, for example, and your negatives are consistently underexposed, lower the ISO to a setting of 80 or 64. If your negatives are consistently overexposed, increase the ISO setting on your meter. Testing is imperative here in order to establish the right working ISO for your equipment and workflow habits.

Before you begin fine-tuning your exposure and development, it is important to know the difference between errors in exposure and errors in development. Underexposed negatives lack sufficient shadow detail; underdeveloped negatives lack sufficient contrast. Overexposed negatives lack highlight detail; overdeveloped negatives have excessive contrast but may have sufficient highlight detail. If you are unsure, and most become unsure in the areas of overdevelopment and overexposure, make a test print from the suspect negative. If you cannot obtain highlight detail by printing

the negative darker, then the negative is overexposed. If highlight detail appears but only when the negative is printed down, then you have overdeveloped the negative.

○ METERING

Because exposure is so critical to producing fine portraits, it is essential to meter the scene properly. Using the in-camera light meter may not always give you consistent and accurate results, although the light-pattern recognition systems used in today's 35mm SLR metering systems seem almost foolproof. Even with sophisticated multi-pattern, in-camera reflected meters, certain brightness patterns can influence the all-important skin tones. Usually these meters are center-weighted because that's where most people place their subjects within the frame. The problem arises from the meter's function, which is to average all of the brightness values it sees to produce a generally acceptable exposure.

Put more accurately, the in-camera meter wants to turn all it sees into 18-percent gray. This is rather dark even for a well-suntanned or dark-skinned individual. So, if using the in-camera meter, meter from an 18-percent gray card (large enough to fill most of the frame) held in front of the subject. If using a handheld reflected-type meter, do the same thing—take a reading from an 18-percent gray card.

A handheld incident flashmeter is essential for working indoors and out, but particularly crucial when mixing flash and daylight. It is also useful for determining lighting ratios. Flashmeters are invaluable when using multiple strobes and when trying to determine the overall evenness of lighting in a large-size room. Flashmeters are also ambient incident-light meters, meaning that they measure the light falling on them and not light reflected from a source or object as the in-camera meter does.

One of David Bentley's specialties is photographing large family groups. Here he used beautiful backlighting for elegant rim light. For his frontal lighting, he relied on a mix of daylight and off-camera flash, set two stops less than the ambient frontal reading. It is important in these situations to not let the backlighting influence the exposure. When pointing the handheld incident meter at the lens from the subject position, shield the top edge of the hemisphere (dome) from the backlight.

The reasons for the switch to digital are numerous—from instant verification of the image composition, expression, and exposure to ease of shooting, to the lack of film and processing costs. Aside from digital's speed and convenience, factor in the client's feelings about digital. Most consumers regard photographers who shoot with digital SLRs as upscale and cutting edge, People who are in-demand and at the top of their profession—in short, the right person for the job. In this chapter, we'll investigate the aspects of digital photography that most affect the creation of family portraiture.

○ FOCAL-LENGTH FACTORS

Full-frame image sensors now exist, but most are still smaller than the 1 x 1.5-inch (24 x 36mm) 35mm frame size. While the chip size does not necessarily affect image quality or file size, it *does* affect lens focal length. With sensors smaller than 24 x 36mm, all lenses get effectively longer in focal length. This is not usually a problem where telephotos and telephoto zooms are concerned, as the maximum aperture of the lens doesn't change. However, when your expensive wide-angles or wide-angle zooms become significantly *less* wide on the digital camera body, it can be somewhat frustrating. A 17mm lens, for example, with a 1.4x focal-length factor becomes a 24mm lens.

A very positive development that is occurring at this writing is that camera manufacturers who have committed to smaller chip sizes have started to introduce lens lines specifically designed for digital imaging. The circle of coverage (the area of focused light falling on the film plane or digital-imaging chip) is smaller and more collimated to

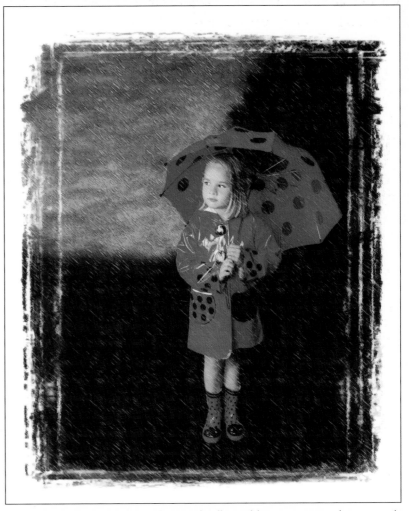

A new red slicker with matching umbrella and boots is more than enough reason to have a special portrait made. Deborah Ferro created this lovely image in the studio and later added "digital rain"—almost a cartoon-like feature—and a Polaroid border treatment for a truly special image.

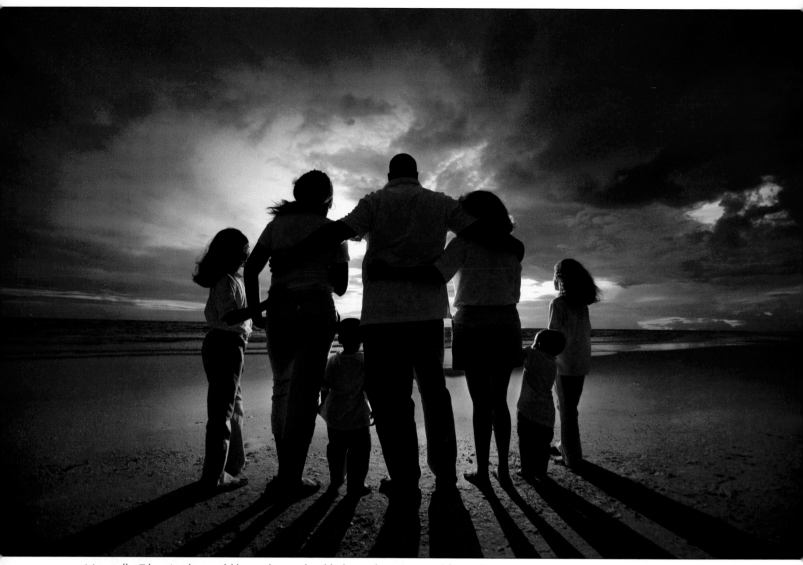

Normally, Tibor Imely would have the sun backlighting the group and fire a flash to illuminate the shadows. But he was struck by the radial patterns of the shadows and to a lesser extent in the sky. The result, which was "washed" in violet in Photoshop to enhance the colors of the Florida sunset, is called *Neon Blue Twilight*. Delicate vignetting, again in Photoshop, darkens the corners and draws your eye to the center of the pattern.

compensate for the smaller chip size. Thus, the lenses can be made more economically and smaller in size, yet still offer as wide a range of focal lengths as traditional lenses.

The only drawback is that photographers used to know the coverage of a given focal length lens, 24mm, for example. Now, one has to know the chip size to know the effect of different focal lengths. Take a 50mm lens on a camera with a 1.6x focal-length factor, for example. That 50mm lens is now an 80mm lens. The great thing is that lens speed does not change. In this example, a 50mm f/1.2 lens is now equivalent to an 80mm f/1.2 lens.

○ ISO SETTINGS

Digital ISOs correlate closely to actual film speeds—the slower the setting, the less noise (the digital equivalent of grain) and the more contrast. Unlike film, however, contrast is a variable you can control at the time of capture (most photographers keep this on the low side, since it is easy to add contrast later, but harder to remove it). Digital ISOs can be increased or decreased between frames, making digital inherently more flexible than film, where you are locked into a single film speed for the duration of the roll.

Shooting at the higher ISOs, like ISO 800 or 1600, produces a lot of digital noise in the exposure. How-

ever, many digital image-processing programs contain automatic noise-reduction filters to combat this. New products, such as nik Multimedia's Dfine, a noise reducing plug-in filter for Adobe Photoshop, effectively reduce image noise post-capture.

○ BLACK & WHITE

Some digital cameras offer a black & white shooting mode. Others do not. Most photographers find the mode convenient, since it allows them to switch from color to black & white in an instant. Of course, the conversion is easily done later in Photoshop, as well.

○ EXPOSURE

Digital exposures are not nearly as forgiving as color negative film. The latitude is simply not there. Most digital photographers compare shooting digital to shooting transparency film, in which exposure latitude is usually ½ stop or less in either direction. With transparency film to err on either side of correct exposure is bad; when shooting digitally, exposures on the underexposed side are still salvageable, while overexposed images, where there is no highlight detail, are all but lost forever. You will never be able to restore the highlights that don't exist in the original exposure. For this reason, most digital images are exposed to ensure good detail in the full range of highlights and midtones and the shadows are either left to fall into the realm of underexposure or they are "filled in" with auxiliary light or reflectors to boost their intensity.

Evaluating Digital Exposures. There are two ways of evaluating exposure of the captured image: by judging the histogram, and by evaluating the image on the camera's LCD screen. By far, the more reliable is the histogram, but the LCD monitor provides a quick reference for making sure things are okay. The histogram is a graph associated with a single image file that indicates the number of pixels that exist for each brightness level. The range of the histogram represents 0–255 steps from left to right, with 0 indicating "absolute" black and 255 indicating "absolute" white.

In an image with a good range of tones, the histogram will fill the length of the graph (i.e., it will have detailed shadows, highlights, and everything in between). When an exposure has detailed highlights,

these will fall in the 235–245 range; when an image has detailed blacks, these will fall in the 15–30 range (RGB mode). The histogram may show detail throughout (from 0–255) but it will trail off on either end of the graph.

Histograms are scene-dependent. In other words, the number of data points in the shadows and highlights will directly relate to the subject and how it is illuminated and captured. The histogram also gives an overall view of the tonal range of the image, and the "key" of the image. A low-key image has its detail concentrated in the shadows (a higher number of data points at the dark end of the scale); a high-key image has detail concentrated in the highlights. An average-

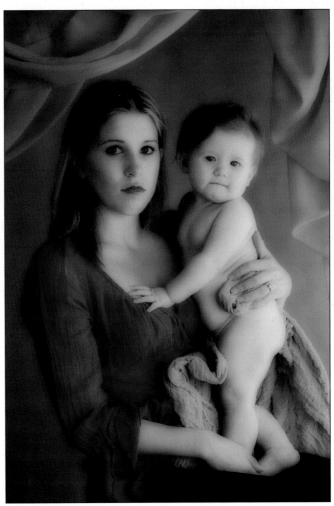

This amazing portrait by Jennifer George Walker has all the elements of great art, including complexity and a sense of uncertainty that makes the viewer wonder. Aside from its great composition and light, it has been masterfully diffused to soften the edges of everything, idealizing the baby and young girl. The trick with selective diffusion in Photoshop is knowing how far to go.

Marcus Bell created this amazing portrait of a young girl at the beach. The image was made at twilight with the sun barely on the horizon, creating a soft directional light. The fading sunlight produces noticeable catchlights in her eyes. Marcus included just enough of the blue ocean to be able to match the blue of her shirt later in Photoshop. The image was photographed with a Canon EOS 10D, zoom lens at the 70mm setting, ISO 800 setting at an exposure of ½₂₅₀ at f/5.6. He used one of the camera's pattern metering programs and verified his exposure on the LCD.

key image has detail concentrated in the midtones. Typically, an image with full tonal range has a substantial number of pixels in all areas of the histogram.

Overexposure is indicated when data goes off the right end of the graph, which is the highlight portion of the histogram. This means that the highlights are lacking image detail, tone, and color. In a properly exposed image, the image information on the right side of the graph almost reaches the end of the scale but stops a short distance before the end.

When an image is underexposed the image information in the histogram falls short of the right side and bunches up on the left side. Although it is true that it is better to be have an underexposed image as opposed to an overexposed one, it will never look as good as a

properly exposed image. You can correct for underexposure in Photoshop's Levels or Curves adjustments, but it is time-consuming to adjust exposure in this manner.

○ LCD PLAYBACK

The size and resolution of the camera's LCD screen are important, as the LCD is highly useful in determining if you got the shot or not. LCD screens range from about 1.8 inches to 2.5 inches and resolutions range from around 120,000 dots to 220,000 dots. As important as the physical specifications of the LCD is the number of playback options available. Some systems let you zoom in on the image to inspect details. Some let you navigate across the image to check different areas of the frame in close-up mode. Some camera systems allow you a thumbnail or proof-sheet review. Some of the more sophisticated systems offer histogram and highlight-point display to determine if the highlight exposure is accurate throughout the image.

○ RAW VS. JPEG MODE

Digital SLRs offer the means to shoot in several modes, but the two most popular are RAW and JPEG.

RAW. Shooting in the RAW mode requires the use of RAW file-processing software to translate the file information and convert it to a useable format. RAW files contain more data than JPEG files, which feature some level of file compression. If you shoot in RAW mode, be sure to back-up your files as RAW files; these are your original images and contain the most data.

RAW files offer the benefit of retaining the highest amount of image data from the original capture. If you are shooting on the go and need faster burst rates, then RAW files will slow you down. They will also fill up your storage cards or microdrives much quicker because of their larger file size. RAW files do, however, offer you the ability to almost completely correct for underexposure.

RAW File Processing. Only a few years ago RAW file-processing software was limited to the camera manufacturer's software, which was often slow and difficult to use. Over time, the software has improved drastically and, with the introduction of independent software like Adobe Camera RAW and Phase One's Capture One DSLR, RAW file processing is not nearly as daunting. Further, new cameras with bigger buffers and buffer upgrades for existing cameras have improved the situation to the point where many pros shoot RAW files much of the time.

Cal Landau is a fine printer in the traditional sense of the word. "I believe printing your own work is far more efficient," Cal says. "I have total control over my images from capture to finishing. Printing your own work eliminates mistakes caused by lack of communication between the photographer and the lab. Digital printing can be done on any kind of paper, such as watercolor, LexJet 10 mil Satin, LexJet Archival Matte, or any number of art papers from Crane and Hahnemühle, which gives clients a greater selection of products." Cal prints exclusively on the Epson 2200 and 7600 printers.

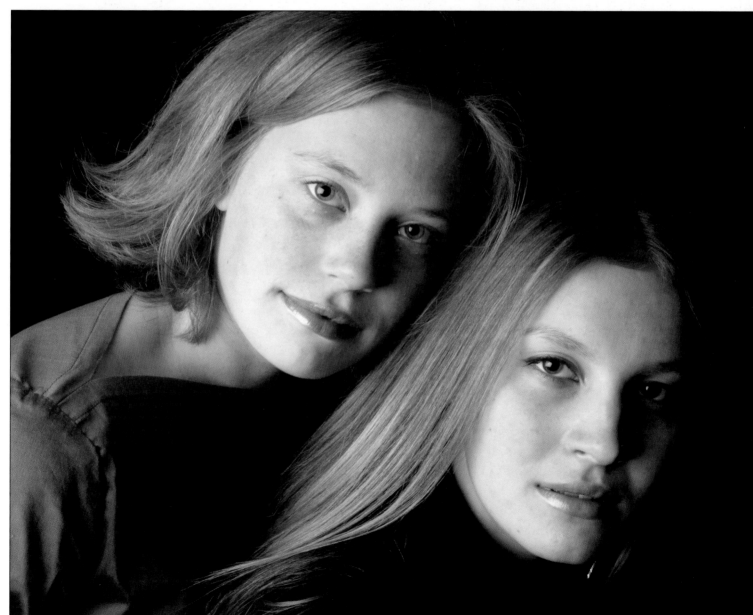

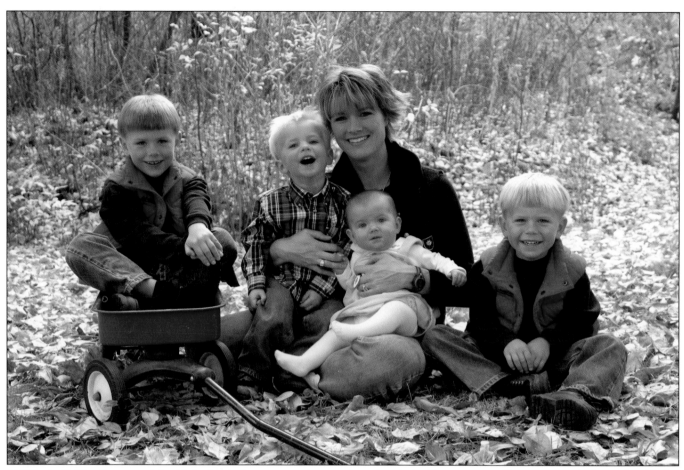

This beautiful family portrait by Melanie Nashan was made in unaltered sunlight. She positioned her group with the sun backlighting them, providing a soft hair and rim light. The natural foliage illuminated the front sides of the family. Melanie biased her exposure toward the shadows so that the highlights would be about $\frac{1}{3}$ stop overexposed—hot, but not lacking detail. Melanie used a Canon EOS D60 and 35mm lens at ISO 200. The exposure was $\frac{1}{45}$ second at f/4.3.

The first step after shooting RAW files is to access them and save them for editing, storage, and output. You can access your images using a few options, including the software supplied with your camera or photo-editing software that recognizes the RAW file type. Usually, image-browsing software is used to initially access the images. Your camera manufacturer may supply this software or it may be third-party software.

After displaying and verifying that all of the files exist on the card, save a version of all of your source files prior to making any modifications or adjustments. And then, make another copy of all of your source files. Most people use CD-ROMs for this purpose, because the medium is inexpensive and writes quickly from most computers. You can also save your source files to an auxiliary hard drive or DVDs.

Get into the habit of creating multiple versions of your work in case you ever need to work back through your workflow process to retrieve an earlier version of a file. Once backups are made you can process the RAW files, after certain general parameters are set. You will need to establish things like your default editing program (i.e., Photoshop) and destination folder, file names, and so forth.

Files can be processed individually or batch-processed. You can even apply certain characteristics to the entire batch of images—white balance, brightness, tagged color space, and more. Remember that your original capture data is retained in the source image file. Processing the images creates new, completely separate files. You will also have an opportunity to save the file in a variety of file formats, depending on what is most convenient to your image-editing workflow.

JPEG. Some photographers prefer to shoot in the JPEG Fine mode (sometimes called JPEG Highest Quality). Shooting in JPEG mode creates smaller files,

so you can save more images per CF card or storage device. It also does not take as long to write the JPEG files to memory, which allows you to work much more quickly. As a result, shooting in the JPEG Highest Quality mode provides convenience and speed while maintaining the integrity of the file.

The biggest drawback to JPEG files is that they are a "lossy" format, meaning that they are subject to degradation by repeated opening and closing. Most photographers who shoot in JPEG mode eventually save the file to a "lossless" TIFF format so that that it can be saved again and again without degradation.

METADATA

DSLRs give you the option to tag your digital image files with data, which often includes the date, time, and camera settings. In Photoshop, go to File>File Info and select EXIF Data in the pull-down menu to see all of the data that your camera automatically tags with each file. Depending on camera model, various other information can be written to the EXIF file, which can be useful for either the client or lab. You can also add your copyright symbol (©) and notice, either from within Photoshop or from your camera's metadata setup files. Adobe Photoshop supports the information standard developed by the Newspaper Association of America (NAA) and the International Press Telecommunications Council (IPTC) to identify transmitted text and images. This standard includes entries for captions, keywords, categories, credits, and origins from Photoshop.

REFORMAT YOUR CARDS

After you backup your source files, it's a good idea to erase all of the images from your CF cards and then reformat them. It isn't enough to simply delete the images, because extraneous data may remain on the card, possibly causing data interference. After reformatting, you're ready to use the CF card again.

Never format your cards prior to backing up your files to at least *two* sources. Some photographers shoot an entire job on a series of cards and take them back to the studio prior to performing any backup. Others refuse to fill an entire card at any time; instead opting to download, back up, and reformat cards directly during a shoot. This is a question of preference and security. Many photographers who shoot with assistants train them to perform these operations to guarantee the images are safe and in hand before anyone leaves the location.

COLOR SPACE

Many DSLRs allow you to shoot in Adobe RGB 1998 or sRGB color space. There is considerable confusion over which is the "right" choice, as Adobe RGB 1998 offers a wider gamut than sRGB. Some photographers reason that it only makes sense to include the maximum range of color in the image at capture. Others feel that sRGB is the color space of inexpensive point-and-shoot digital cameras, and therefore not suitable for professional applications.

The answer, however, is clearer after reading a recent white paper from Fuji, which recommends photographers "stay inside the sRGB color space by capturing and working in the sRGB gamut. If the photographer's camera allows the 'tagging' of ICC profiles other than sRGB, we recommend selecting the sRGB option for file creation. The native color space of many professional digital cameras is sRGB, and Fujifilm recommends the sRGB option as the working space for file manipulation when using Adobe Photoshop along with a fully calibrated monitor. End users/photographers who alter the color space of the original file by using a space other than sRGB, without being fully ICC- [color profiles for devices, including cameras, monitors, and printers] aware, are actually damaging the files that they submit to their labs."

There is also another school of thought. Many photographers who work in JPEG format use the Adobe 1998 RGB color space all the time, right up to the point that files are sent to a printer or out to the lab for printing. The reasoning is that since the color gamut is wider with Adobe 1998 RGB, more control is afforded. Claude Jodoin is one such photographer who works in Adobe 1998 RGB, preferring to get the maximum amount of color information in the original file, then edit the file using the same color space for maximum control of the image subtleties.

Is there ever a need for other color spaces? Yes. It depends on your particular workflow. For example, all

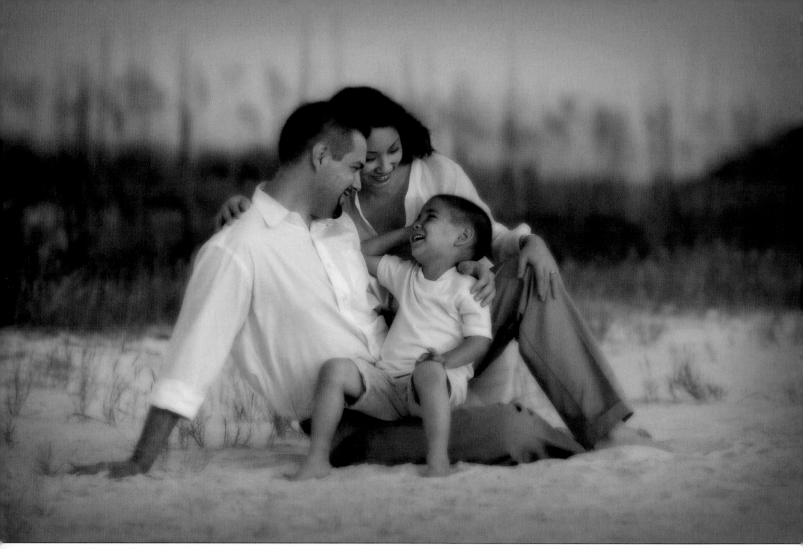

White balance is a color-correcting function of digital cameras and video that is unique. The color of daylight at sunset is very warm—orange-red. However, the eye wants to see white shirts as white. While the highlights of the clothing in this photo are warm-toned, the shadows are neutral gray, as the eye expects to see them. The various white-balance settings in digital cameras give you precise control over virtually any lighting condition. This wonderful portrait is by Tibor Imely.

the images you see in this book have been converted from their native sRGB or Adobe 1998 RGB color space to the CMYK color space for photomechanical printing. As a general preference, I prefer images from photographers be in the Adobe 1998 RGB color space, as they seem to convert more naturally to CMYK.

Ironically, if you go into Photoshop's color settings mode and select U.S Pre-press Defaults, Photoshop automatically makes Adobe RGB 1998 the default color space. By the way, out of the box, Photoshop's default color settings when installed are for Web, which assumes sRGB color space, and color management is turned off.

○ WHITE BALANCE

White balance is the camera's ability to correct color when shooting under a variety of different lighting conditions, including daylight, strobe, tungsten, and fluorescent lighting. DSLRs have a variety of white-balance presets, such as daylight, incandescent, fluorescent—some even have the ability to dial in specific color temperatures in Kelvin degrees. These settings are often related to a time of day. For example, pre-sunrise white-balance setting might call for a setting of 2000K, while a heavy, overcast day might call for a white-balance setting of 8000K. Most DSLRs also have a provision for a custom white balance, which is essential in mixed light conditions, most indoor available-light situations, and with studio strobes.

White balance is particularly important if you are shooting JPEG files. It is not as critical if shooting in RAW file mode, since these files contain more data than the compressed JPEG files and are easily remedied later.

A good system that many photographers follow is to take a custom white balance of a scene where they are unsure of the lighting mix. By selecting a white area and neutralizing it with a custom white balance, you can be assured of a fairly accurate rendition.

Wallace ExpoDisc. An accessory that digital pros swear by is the Wallace ExpoDisc (www.expodisc .com). The ExpoDisc attaches to your lens like a filter and provides perfect white balance and accurate exposures whether you are shooting film or digitally. The company also makes a Pro model that lets you create a warm white balance at capture. Think of this accessory as a meter for determining accurate white balance.

○ **BATTERY POWER**

Since you don't need motorized film transport, there is no motor drive or winder on DSLRs, but the cameras still look the same because the manufacturers have smartly designed the auxiliary battery packs to look just like a motor or winder attachment. While most of these cameras run on AA-size batteries, it is advisable to purchase the auxiliary battery packs, since most digital camera systems (especially those with CCD sensors) chew up AAs like jelly beans. Most of the auxiliary battery packs used on DSLRs employ rechargeable Lithium-ion batteries.

○ **THE MANY ADVANTAGES OF DIGITAL CAPTURE**

Perhaps the greatest advantage of shooting digitally is that when the photographer leaves the event or shooting session, the images are already in hand. Instead of scanning the images when they are returned from the lab, the originals are already digital and ready to be brought into Photoshop for retouching or special effects, and subsequent proofing and

printing. Digital even allows photographers to put together a slide show almost instantaneously.

Another reason why digital has become so popular with today's photographers is that you can change film speed on the fly. For example, if you are shooting a portrait outdoors in shade, you might select ISO 400. Then, you might move to another location, where the light level drops off by two or more stops. With digital, you can simply adjust the film speed to a higher setting, like ISO 1600, to compensate for the lower light level. If you move indoors soon thereafter and are shooting by tungsten room light, you can quickly adjust the white balance to a tungsten or incandescent setting—or rely on the camera's automatic white-balance function to correct the color.

With some camera models, you can also shift back and forth between color and black & white capture, creating even more variety.

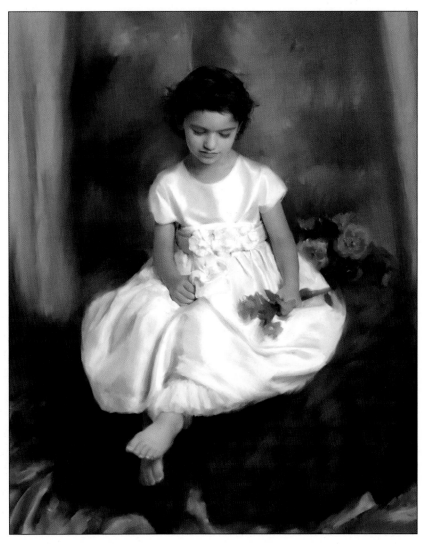

Drapes and fabrics of varying hues all seem to combine kaleidoscopically in this beautiful portrait by Deanna Urs. Deanna is a master at Painter, blending color and image details but leaving important areas relatively unaffected.

4. Posing and Communication

When more than one person is pictured in a portrait, the traditional rules of posing, dating back to Greek civilization and refined throughout the centuries, have to be bent—if not shattered completely. As one noted portrait photographer, Norman Phillips, says, "The most important concern in building groups is to be sure they are in focus and properly lighted."

In traditional portraiture of a single person, the fundamental posing and composition help define character in the image. In a group portrait, it is the design created by more than one person that helps to define

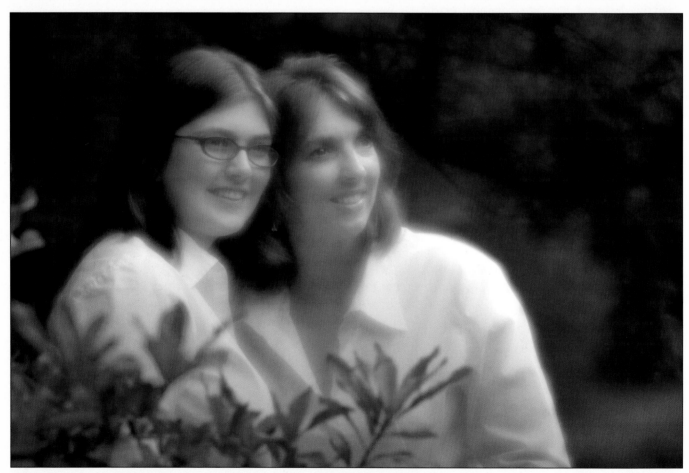

Monte Zucker created a lovely horizontal portrait with two different head/shoulders axes. He chose to have the women lean their heads in toward each other for intimacy. Notice that each face has a slightly different head position. The way their bodies are positioned helps form a triangular base to the composition of the portrait. Using an EF 135mm f/2.8 soft focus lens on a Canon EOS 10D heavily diffused the image. The image was exposed for ¹⁄₇₅₀ second at f/2.8.

the image. As you will see, there are a number of tricks at play that you probably have never noticed.

It should be noted here that family portraiture is much less formal than it used to be. Posing is more relaxed and many of the guidelines mentioned here are not always used. However, they are included in this chapter so that you may have as many posing alternatives as possible at your disposal.

When "designing" family groups, which may take some time, it is important that your subjects are reasonably comfortable. This is particularly true for large groups. Posing stools and benches allow the subject comfort, and also provide good, upright posture. These are fine for studio work, but what about outdoors or on location? You must find a spot—a hillside or an outdoor chair, for example—that will be comfortable for the duration of the shooting session. This will help your posing appear natural. If your subjects are to appear relaxed, then the poses must be typical to them—something they would normally do.

○ HEAD-AND-SHOULDERS AXES

A fundamental of good portraiture is that the subjects' shoulders should be turned at an angle to the camera (shoulder axis). When the shoulders face the camera straight on, it makes people look wider than they really are and it can lead to a static composition.

Each subject's head should be tilted at a slight angle (head axis). By doing this, you slant the natural line of the person's eyes. When the face is not tilted, the implied line is straight and parallel to the bottom edge of the photograph, leading to a repetitive, static line. With men, the head is more often turned the same direction as the shoulders, but not necessarily to the same degree. With women, the head is often at a slightly different and opposing angle—

Leslie McIntosh created this beautiful portrait of four children at the beach. Notice that even in a spontaneous portrait such as this, the three girls seem to automatically tilt their head toward the near shoulder, a decidedly feminine pose. Leslie made this image at twilight using a barebulb flash fired at between one and two stops less than the ambient light exposure—just enough flash to give a twinkle to the eyes.

toward the near shoulder. By tilting each person's face right or left, the implied line becomes diagonal, making the pose more dynamic. For the most natural look, the tilt of the person's head should be slight and not exaggerated.

One of the by-products of good posing is the introduction of dynamic lines into the composition. If you follow these guidelines, you'll see that the line of the

Frank Frost made this fine portrait of a couple and their pooch. Notice that the head heights are varied to create visual interest and a beautiful pyramid shape is created. Frank also had the couple tilt their heads in toward each other to produce complimentary diagonal lines formed by the line of the eyes. The pooch, who must be an accomplished poser, helped refine the pose by tilting his head away from the man. Shapes and lines are ways to create heightened visual interest in group family portraits.

shoulders now forms a diagonal line, while the line of the head creates a different dynamic line.

○ HEAD POSITIONS

Seven-Eighths View. There are three basic head positions in portraiture. The ⅞ view is created when the subject is looking slightly away from the camera. If you consider the full face as a head-on type of "mug shot," then the ⅞ view is when the subject's face is turned just slightly away from the camera. In other words, you will see a little more of one side of the face than the other from the camera position. You will still see the subject's far ear in a ⅞ view.

Three-Quarter View. This is when the far ear is hidden from the camera and more of one side of the face is visible. With this pose, the far eye will appear smaller because it is more distant from the camera than the near eye. It is important when posing subjects in a

¾ view to position them so that the smallest eye (people usually have one eye that is slightly smaller than the other) is closest to the camera. This way, the perspective makes both eyes appear the same size in the photograph.

Profiles. In the profile, the head is turned almost 90 degrees to the camera. Only one eye is visible. In posing your subjects in a profile position, have them turn their heads gradually away from the camera position just until the far eye and eyelashes disappear from view. If the subject has exceptionally long eyelashes, they will still show up, even when the head is turned 90 degrees or more. These are easily retouched out later.

○ DEFINING LEVELS WITHIN A GROUP

No two heads should ever be on the same level when next to each other, or directly on top of each other.

This type of posing is, as a rule, only done in team photos. Not only should heads be on different levels, but subjects should be as well. In a family group of five people you can have all five on different levels by having one seated, one standing to the left or right, one seated on the arm of a chair, one kneeling on the other side of the chair, and one kneeling down in front with their weight on their calves. Always think in terms of multiple levels. This makes any group portrait more pleasing.

Monte Zucker, who composes very tight, intimate group portraits, has a slightly different take: "I try to never put two heads together at the same level, unless there's another person between them or above or below them."

Regarding proximity of one head to another, be consistent. Don't have two heads close together and two far apart. There should be a more or less equal distance between each. If you have a situation where one person is seated, one standing and a third seated on the arm of a chair (placing the two seated heads in close proximity), then back up and make the portrait a full-length. This minimizes the effect of the standing subject's head being so far from the others.

○ **THE EYES AND COMMUNICATION**

The best way to keep your subjects' eyes active and alive is to engage them in conversation. Look up often while you are setting up and try to find a common frame of interest. Ask questions that might interest any

Two brothers are pictured with one a few inches higher than the other. This may be a function of age or size, but the effect of the asymmetry is to make the portrait even more interesting and visually appealing. Photograph by Larry Peters.

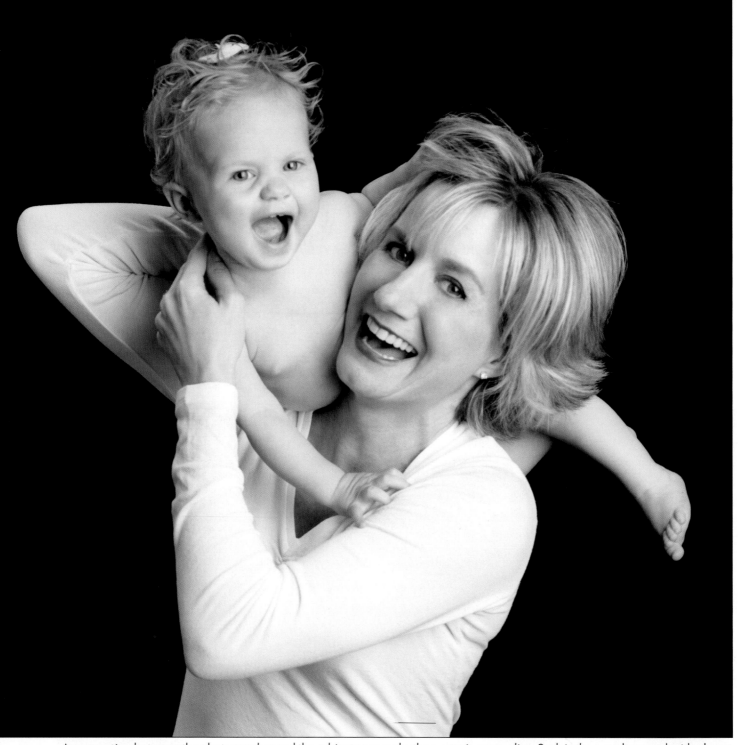

A connection between the photographer and the subjects can make the portrait come alive. Such is the case here and with almost all of Stacy Bratton's portraits. She loves doing what she does and coaxes and plays until things start to happen. Stacy's portraits of babies, which appear throughout this book, are the most varied expressions you will ever see an infant make. Her success relies on the connection.

or all members of the family. If the group is uncomfortable or nervous, you have to intensify your efforts to help them relax. It's all about trust. If they trust that you know what you're doing and you're a pro, your job will be easy. Try a variety of conversational topics until you find one they warm up to and then pursue it.

As you gain their interest, you will take their minds off of the session.

Working with an assistant can help take the pressure off of you, allowing you to be freer in developing a rapport with your group. Bear in mind that families all have their own informal unspoken ways of communi-

cation. You are an outsider, but you can use that fact to your advantage by playing off its humorous aspects.

The direction in which the group is looking is important. Start the portrait session by having the group look at you. Using a cable release with the camera tripod-mounted forces you to become a "host" and allows you to physically hold the group's attention. It is a good idea to shoot a few shots of the group looking directly into the camera, but most people will appreciate some variety. Looking into the lens for too long will bore your subjects.

○ MOUTHS AND EYES

It is a good idea to shoot a variety of portraits, some smiling and some serious—or at least not smiling. People are self-conscious about their teeth and mouths. If you see that the family has attractive smiles, make plenty of exposures of them smiling.

Photographer Stacy Bratton is unbelievably skilled at coaxing the most astounding expressions out of her baby subjects. Posing skills take a back seat to expressions when photographing babies.

One of the best ways to create natural smiles is to praise your subjects. Tell them how good they look and how much you like certain features. Simply saying "Smile!" will produce that lifeless "say cheese" type of expression. By sincere confidence building and flattery you will get the group to smile naturally and their eyes will be engaged.

The mouth is nearly as expressive as the eyes. Pay close attention to your subjects' mouths to be sure there is no tension; this will give the portrait an unnatural, posed look. If you spot someone who needs relaxing, talk to him or her directly, in a calm, positive manner. An air of relaxation relieves tension, so work to achieve that mood.

An area of the face where problems occasionally arise is the frontal part of the cheeks, the area that creases when a person smiles (commonly called the laugh lines). Some people have furrows in this area that look unnaturally deep when they are photographed smiling. If the lines are severe, avoid a "big smile" type of pose.

○ CHIN HEIGHT

Be aware of the effects of too high or too low a chin height. If the chin is too high, the pose will seem "snooty." If the chin height is too low, the neck will look compressed—or, worse, the person will seem to have no neck at all. A medium chin height is, quite obviously, recommended.

○ POSING HANDS

Hands can be a problem in small groups. Despite their small size, they attract attention to themselves, particularly against dark clothing. They can be especially problematic in seated groups, where at first glance you might think there are more hands than there should be for the number of people pictured. This makes it a good idea to hide as many hands as you can.

For men, have them put their hands in their pockets; for women, try to hide their hands in their laps. Flowers, hats, and other people can also be used to hide hands in group portraits. Be aware of these potentially distracting elements and look for them as part of

FACING PAGE—Ordinarily one would pose sisters at different head heights, but in the case of twins—especially twins who have been made to feel good about their missing front teeth—the best plan is to create a mirror image. And by the way, don't bother trying to pose kids' hands. They won't get it. Photograph by Stacy Bratton. **ABOVE**—Hands are always problematic with groups. The more hands you show the greater the problem. In this fine family portrait by Frank Frost, all of the hands pictured are rendered expertly. Even the son's right hand, which is only partially visible, looks normal and "correct."

your visual inspection of the frame before you make the exposure.

If you are photographing a man, folding the arms across his chest is a good, strong pose. Have the man turn his hands slightly inward, so the edge of the hand is more prominent than the top (this gives a natural line to the photograph and eliminates the distortion that occurs when the hand is photographed from the top or head-on). In such a pose, have him lightly grasp his biceps—but not too hard, or it will look like he's cold. Also, remember to instruct the man to bring his folded arms out from his body a little bit. This slims the arms, which would otherwise be flattened against his body, making them and him appear larger.

Women's hands should look graceful. With a standing woman, one hand on a hip and the other at her side is a good standard pose. Don't let the free hand dangle. Instead, have her turn the hand so that the outer edge shows to the camera. Try to "break" the wrist, meaning to raise the wrist slightly so there is a smooth bend and gently curving line where the wrist and hand join. This is particularly important with women whose hands are small, since the "break" in the wrist gives the hand dimension.

In all types of portraiture, a general rule is to show all of the hand or none of it. Don't allow a thumb or half a hand or a few fingers to show. Additionally, you should avoid photographing subjects with their hands pointing straight into the camera lens. This distorts the size and shape of the hands. Instead, have the hands at an angle to the lens. Finally, try to photograph the fingers with a slight separation in between them. This gives the fingers form and definition. When the fingers are closed tightly they appear two-dimensional.

○ THREE-QUARTER AND FULL-LENGTH POSES

As you probably understand by now, the more of the human anatomy you include in a portrait, the more problems you encounter. When you photograph a group in a ¾- or full-length pose, you have arms, legs, feet, and the total image of the body to contend with.

A ¾-length portrait is one that shows the subjects from the head down to a region below the waist. This type of portrait is usually best composed by having the bottom of the picture be mid-thigh or below the knee and above the ankles. Never break the portrait at a joint, as this has a negative (though subconscious) psychological impact.

You should always have the subjects facing one direction or another, usually at a 30- to 45-degree angle to the camera. Additionally, you should have the subjects put their weight on their back feet, rather than distributing their weight evenly on both feet or worse yet, on their front foot. There should be a slight bend in the front knee if a person is standing. This helps break up the static line of a straight leg. The back leg can remain straight.

Have the feet pointing at an angle to the camera. Just as it is undesirable to have the hands facing the lens head-on, so it is with the feet, but even more so. Feet tend to look stumpy, large, and very unattractive when photographed head-on.

When subjects are sitting, a cross-legged pose is sometimes desirable. Have the top leg facing at an angle and not pointing into the camera lens. With a woman who is sitting cross-legged, it is a particularly good idea to have her tuck the calf of the front leg in behind the back leg. This reduces the size of the calves, since the back leg, which is farther from the camera, becomes the most prominent visually. Always have a slight space between the leg and the chair, when possible, as this will slim thighs and calves. And don't allow seated subjects to sit back in the chair with their lower back in contact with the chair back. This thickens the person, especially the torso.

The subjects' arms should never be allowed to fall to their sides but should project outward to provide gently sloping lines that form a "base" to the composition.

FACING PAGE—A ¾-length pose should not "break" at the subject's joints, such as the knees or ankles. Here, Deanna Urs produced a lovely ¾-length pose with elegant lighting and propping. When photographing young people, you do not have to follow the rules about photographing them head on. They are small enough and usually thin enough so that the camera does not add weight by photographing them head on. A pose like this often adds to their natural innocence. Notice how the young girl's hands are flattened on the table to add a base to the composition, yet they are not smashed flat against the wood. There is space beneath each hand to show dimension and form.

This is achieved by making subjects aware that there should be a slight space between their upper arms and torsos. This triangular base attracts the viewer's eye upward, toward the subjects' face. This little trick of keeping the arms apart from the torso also helps the arms look well defined and slender, which is particularly important to women.

As you will see, the seated pose is often the cornerstone of the small group. A mother or grandmother is often seated at the center of the group, and the rest of the group is designed around her.

It should be noted that in any discussion of subject posing, the two most important points are that the poses appear natural (one that the people would typically fall into) and that the subjects' features be undistorted. If the pose is natural and the features look normal, perspective-wise, then you have achieved your goal, and the portrait will be pleasing to you and the subject.

Any pose that you contrive for your subjects should be believable and true. Here, Jennifer Maring photographed a little girl in her room completely oblivious to the camera or photographer. She's just simply enjoying her rocking horse. Jennifer let the window light wash over the scene without fill light, making it more believable and innocent.

5. Composition and Design

Composition for groups is much different than composition for individual portraits. The rules remain the same, but the difference is that a member or several members of the group become the primary areas of interest. For example, the grandparents or parents in a family portrait are the main centers of interest and, as such, should occupy a prime location within the composition.

Fran Reisner used opposing segments of the print area to place primary and secondary points of interest. The old bicycle is part of the story of this couple and, as such, Fran wanted it pictured in a current portrait. Notice how the eye goes back and forth between the areas. Fran also did a lot of artist's rendering on the file to make it look like a charcoal drawing.

There are beautiful design elements at work in this portrait by Fran Reisner. First, the father and child are at a perfect intersecting point in the rule of thirds. Second, the pose creates a strong diagonal through the image. Third, the position of the pair gives the portrait direction. The soft, warm twilight creates an emotional feel, and the father's large hands, which engulf the small child, make it appear as if he has created a safe, wonderful place for his child, which no doubt he has.

○ THE RULE OF THIRDS

One of the basics in image composition is the rule of thirds. The rectangular viewing area is cut into nine separate squares by four lines. Where any two lines intersect is an area of dynamic visual interest. The intersecting points are ideal spots to position the main subjects in the group.

The main point of interest does not necessarily have to fall at an intersection of two lines. It could also be placed anywhere along one of the dividing lines.

In close-up group portraits, the eyes are the areas of central interest. Therefore, it's wise to position the subject's eyes on a dividing line or at an intersection of two lines.

In a ¾- or full-length portrait, the faces are the centers of interest; thus the primary subject's face should be positioned to fall on an intersection or on a dividing line. This is important, because if it is a portrait of a bride and groom, the bride should be configured prominently.

In doing environmental portraiture, where the surroundings play a big part in the design of the image, the rule of thirds is crucial to use for placing primary and secondary points of interest.

○ THE GOLDEN MEAN

The golden mean represents the point where the main center of interest should lie, and it is an ideal compositional type for portraits, whether individual or group.

The golden mean is found by drawing a diagonal from one corner of the frame to the other. A second line is then drawn from one or both of the remaining corners so that it intersects the first line perpendicularly. By doing this, you can determine the exact proportions of the golden mean for either horizontal or vertical photographs.

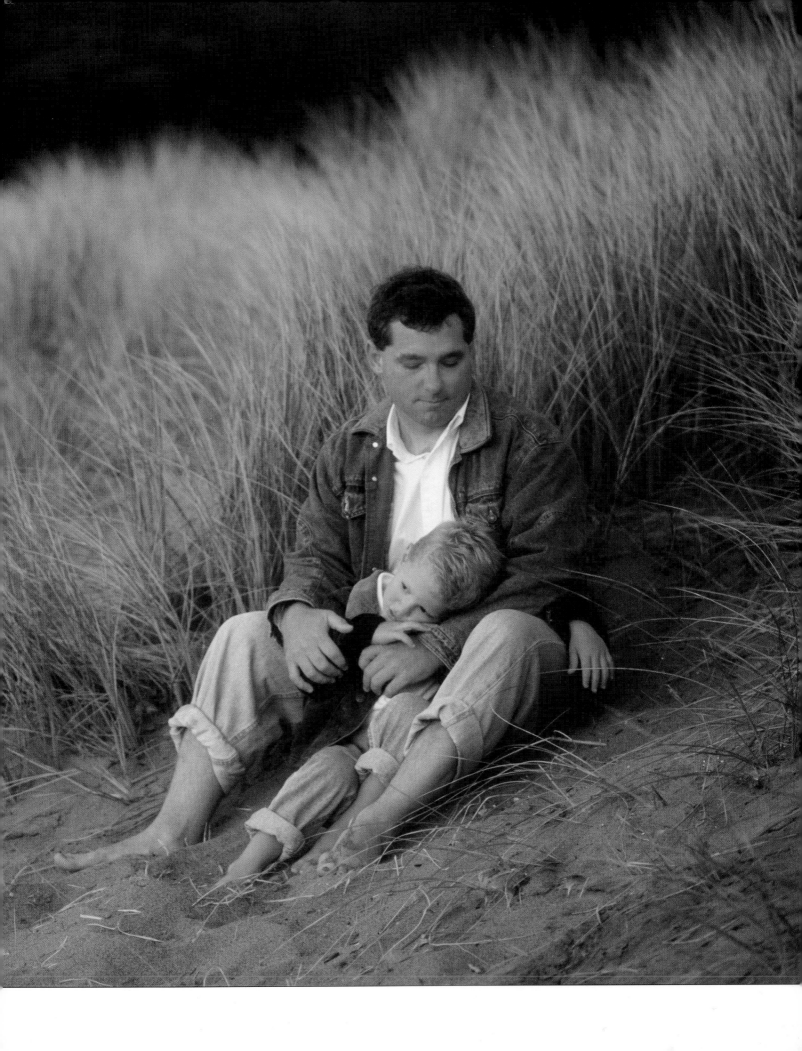

The rule of thirds and the golden mean are two ways of achieving dynamic compositions in group portrait photography. In each case, the center of interest should be placed on or near an intersection of two lines within the picture rectangle. Examine the portraits in this chapter and see if you can find the intersections within the frame where the centers of interest lie. Diagrams by Shell Dominica Nigro.

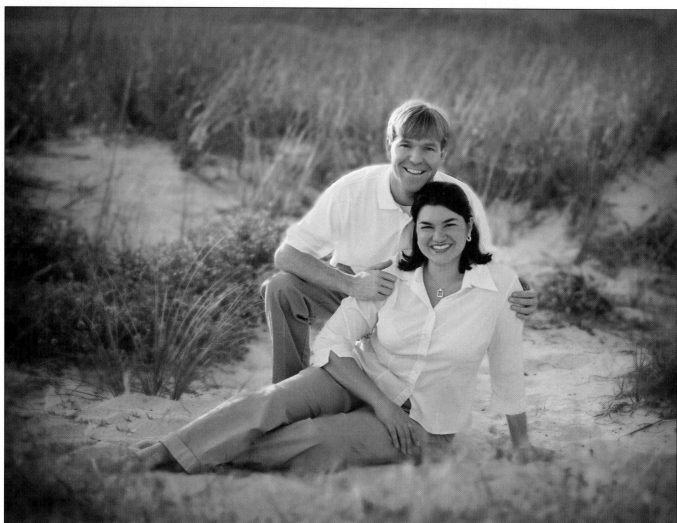

There is some sophisticated design going on in this portrait by Tibor Imely, made as a secondary portrait from a big family shoot. If you look at the white sand in the background, it forms an "X" pattern. The couple is positioned right in the center of the pattern. The woman's right leg acts like an extension of the diagonal line started by the sand behind her, making the portrait appear to possess long, flowing diagonal lines, which are very pleasing to the eye. The use of soft foreground and background elements, sea oats, makes the portrait even more effective.

Beautiful design doesn't happen by accident. In this wonderful portrait by Deanna Urs, you will find a statuesque pyramid shape composed of the entire group and a lovely S curve created by the mother's pose. Deanna used rich fabrics to drape her subjects, lending a timeless atmosphere to the portrait. The beautiful flowing lines of the people offset all of the square lines and edges found in the background props.

○ LINES AND SHAPES

As you will see, designing successful family portraits depends on your sensibility of the intangible: those implied lines and shapes in a composition.

Lines. A line is an artistic element used to create visual motion within the portrait. It may be implied by the arrangement of the family members, or inferred, by grouping various elements within the scene. The photographer must be able to recognize real and implied lines within the photograph.

A real line is one that is obvious—a horizon line, for example. An implied line is one that is not as obvious; the curve of the wrist or the bend of an arm is an implied line. Real lines should not cut the photograph into halves. It is better to locate these at one-third points within the photograph.

Implied lines, like the arms and legs of the group, should not contradict the direction or emphasis of the composition, just modify it. These lines should provide gentle, not dramatic changes in direction, and again, they should lead to the main point of interest.

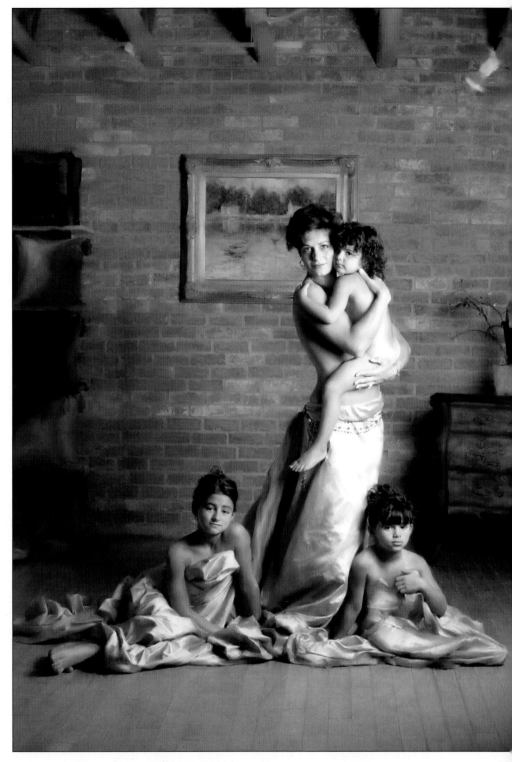

Lines that meet the edge of the photograph—real or implied—should lead the eye into the scene and not out of it, and they should lead toward the subject. A good example of this is the country road that is widest in the foreground and narrows to a point where the subjects are walking. These lines lead the eye straight to the subjects. By the way, the point at which the road in this example narrows to a point on the horizon is known as the vanishing point.

Shapes. Shapes are groupings of like elements: diamond shapes, circles, pyramids, etc. Usually, it is a collection of faces that forms this type of pattern. Shapes are used to produce pleasing designs within the composition that guide the eye through the picture.

ABOVE—The pyramid is the one of the most pleasing shapes to the eye and is often used in photographing large groups. The simple shape brings order to chaos. This image by Tibor Imely displays perfect color coordination and beautiful lighting created by the twilight. When the sun has set below the horizon, its rays continue to light the overhead sky and clouds, creating the softest most beautiful light of the day. Tibor uses no fill light when working at this location, which he frequents often because of the light and pleasant sea-oats background. **LEFT**—Amidst this beautifully posed image you will find a delightful S curve meandering through the composition, almost unnoticeably. Within the posing you will find various triangles and overlapping triangles that are a result of expert group posing. This image is by Robert and Suzanne Love.

Pleasing Compositional Forms. The S-shaped composition is perhaps the most pleasing of all. The center of interest will fall on either a third line or a golden mean, but the remainder of the composition forms a gently sloping S shape that leads the eye through the photograph and to the main point of interest. The Z shape is a close relative to the S-shaped design.

Another pleasing form of composition is the L shape or inverted L shape, which is observed when the group's form resembles the letter L or an inverted letter L. This type of composition is ideal for reclining or seated subjects. These compositional forms may encompass line alone or line and shape to accomplish the pattern.

Direction. Regardless of which direction the subjects are facing in the photograph, there should be slightly more room in front of the group on the side toward which they are facing.

For instance, if the family is looking to the right as you look at the scene through the viewfinder, then there should be more space to the right side of the subjects than to the left of the group in the frame. This gives the image a visual sense of direction.

Even if the composition of the image is such that you want to position the family group very close to the center of the frame, there should still be slightly more space on the side toward which the group is turned.

In this beautiful portrait by Fran Reisner, the sisters are positioned to the left of center, moving into the frame, creating a strong sense of direction. They are positioned at one of the points of interest according to the rule of thirds. The field of wheat, with its horizontal lines from foreground to horizon, contrasts the strong vertical shapes of the young girls.

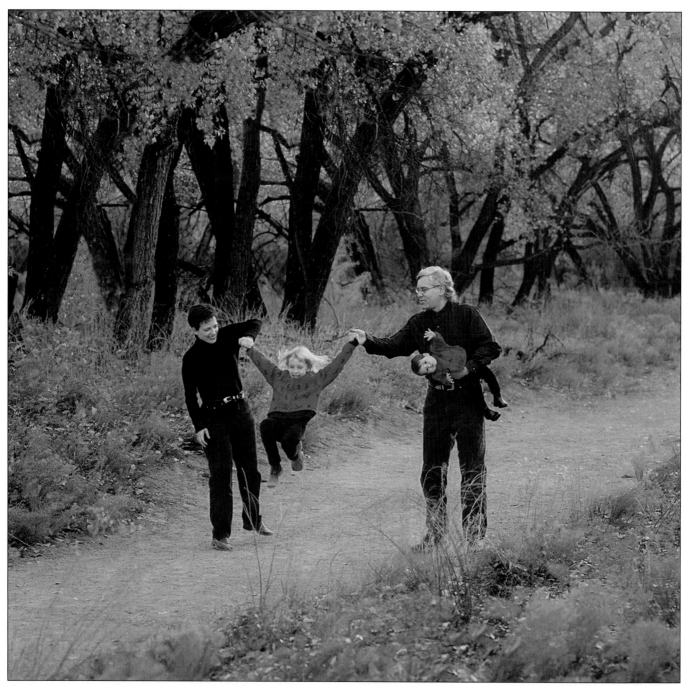

This portrait by Frank Frost combines the warm tones of autumn with the stark black and red outfits of the family. The strong diagonal line runs through the composition, giving it a dynamic quality and a sense of direction. The tones throughout the image coordinate and unify the photograph.

At first, such an arrangement may seem to be a foreign concept, but the more you learn to recognize these elements, the more they will become an integral part of your group compositions.

As in any artistic venture, the goal of the family-portrait photographer is to provide visual direction and movement in the image, guiding the viewer's eye through the composition in an interesting way. The opposite of this is a static image, where no motion or direction is found and the viewer simply "recognizes" rather than enjoys all of the elements in the photo.

○ SUBJECT TONE

The eye is always drawn to the lightest part of a photograph. The rule of thumb is that light tones advance visually, and dark tones retreat. Therefore, elements in the picture that are lighter in tone than the subject will

be distracting. Bright areas, particularly at the edges of the photograph, should be darkened either in printing, in the computer, or in-camera (by masking or vignetting) so that the viewer's eye is not drawn away from the subject.

There are some portraits where the subject is the darkest part of the scene, such as in a high-key portrait with a white background. This is the same basic prin-

ciple at work; the eye travels to the region of greatest contrast.

Regardless of whether the main subject is light or dark, it should dominate the rest of the photograph either by brightness or by contrast.

Whether an area is in focus or out of focus has a lot to do with determining the amount of visual emphasis it will receive. A light-colored background that is

It's amazing how nature sometimes cooperates with a photographer. Here, the Black-eyed Susans in the background seem to provide a well conceived frame around the family. The daughters' ribbons match exactly the color of the flowers. The photographer, Frank Frost, carefully burned in areas of tone that might compete with the family so that your focus is drawn to them. Also notice the strong triangle shape created by the composition, offset on a rule-of-thirds line to create a dynamic composition.

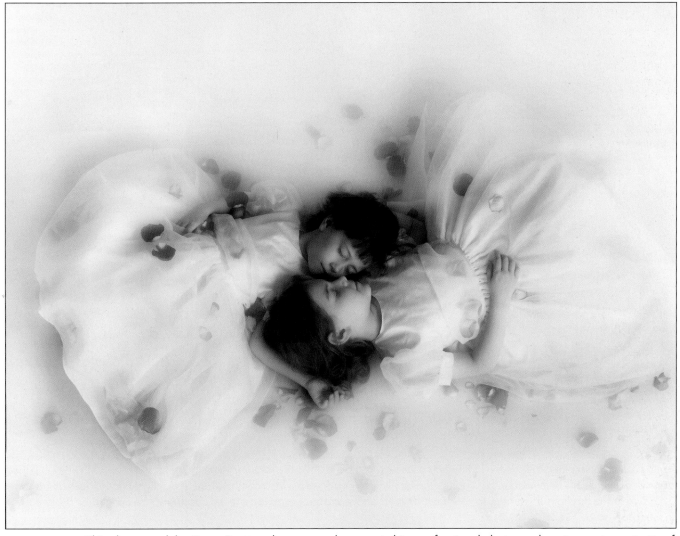

FACING PAGE—This photograph by Stacy Bratton shows you why parents hire professional photographers to create portraits of their children. This is such an innovative image, made even more effective by shallow depth of field and a relatively slow shutter speed that blurs the child's hair. And the expression is priceless. Everything about the image is original and fresh. **ABOVE**—Tension and balance are the two most effective ways to achieve visual interest in a photograph. Here, in Jennifer Maring's beautiful portrait of sisters, you can see both states at work. The balance and tension are derived from the same area, the forms of the two sisters, which loosely resembles the infinity sign or numeral 8, a highly symmetrical symbol. The imbalance or tension comes from the same place—all of the deviations that make the two matching forms different; for example one girl is bigger than the other, one's dress is less perfectly shaped than the other, and so on.

lighter than the group, but distinctly out of focus, will not necessarily detract from the family. It may, in fact, enhance and frame the group, keeping the viewer's eye centered on the subjects.

The same is true of foreground areas. Although it is a good idea to make them darker than your subject, sometimes you can't. If the foreground is out of focus, however, it will detract less from the group, which, hopefully, is sharp.

A technique that is becoming popular is to diffuse an area of the photograph you want to minimize or use to focus attention on your main center of interest. This is usually done in Photoshop by selecting the area and "feathering" it so that the diffusion effect diminishes the closer you get to the edge of the selection.

Expert family portrait photographers insist on tight control over wardrobe for a big family photograph. Instead of dictating one "uniform" for the entire family, they will define complementary color schemes. For example, where multiple families are displayed, each will be in a different outfit—khaki and red, or denim and white. Other families within the group will have

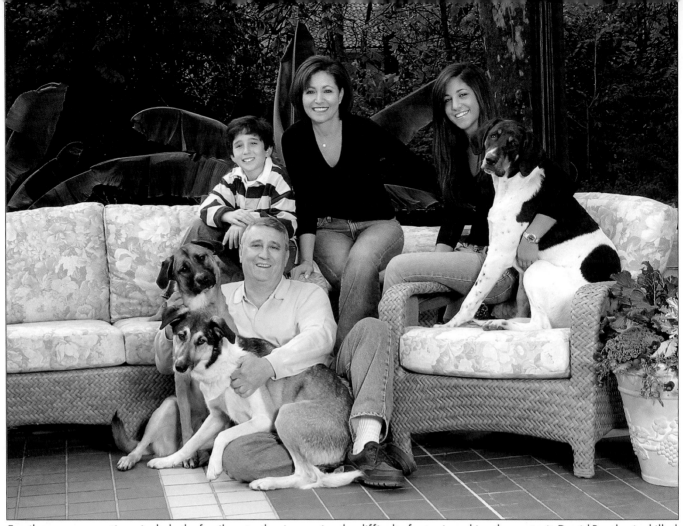

Family groups sometimes include the family pets, thus increasing the difficulty factor in making the portrait. David Bentley is skilled at such family groups and managed to capture the family in the backyard with a combination of daylight and fill flash at the same exposure as the daylight. If you think the dogs are being friendly and cooperative, note the death-grip the dad has on the two dogs in the foreground.

different coordinating outfits—khaki and yellow, or denim shirts and khaki pants. The result is uniformity and diversity.

○ TENSION AND BALANCE

Once you begin to recognize real and implied lines and to incorporate shapes and curves into your family portraits, you need to become aware of the concepts of tension and balance. Tension, or visual contrast, is a state of imbalance in a photograph—a big sky and a small subject, for example, is a situation having visual tension.

Although tension does not have to be "resolved" in an image, it works in tandem with the concept of balance. As you examine the photographs in this book and read the captions, you will hear these terms referred to often. For example, a group of four on one side of an image and two subjects on the other side of the frame produce visual tension. They contrast each other because they are different sizes and not necessarily symmetrical. But the photograph may be in a state of perfect visual balance by virtue of what falls between these two groups, or for some other reason. For instance, using the same example, these two different groups could be resolved visually if the larger group is wearing dark clothes and the smaller group is wearing brighter clothes. The eye then sees the two groups as more or less equal—one group demands attention by virtue of its size, the other gains attention by virtue of its brightness.

These strategies are subjective to a large extent, but there is no question that the eye/brain reacts favorably to both balance and visual tension and they are active ingredients in great photography.

efore we dive into techniques for arranging groups for family portraits, let's take a moment to look at children's portraits, since these are almost always a part of the overall family-portrait session. In recent years, children's portraiture has become highly specialized. While many parents still opt to have the kids photographed at the local department store, discriminating customers realize that they don't get much for their money when they go that route. Many studios, while offering a variety of photographic services, such as fine portraits or weddings, also offer fine children's portraiture. Some photographers even work exclusively with children.

However, working with babies, small children, and teenagers can be the most exasperating profession on earth. Even if you do everything perfectly—beautiful

Marcus Bell chose a full-length pose to reveal the beauty and character of the child. Marcus photographed the child with a large softbox close to the floor, where the baby was posed. He wanted the entire child sharp, so he chose an angle that would capture the sharpness from his nose to his toes. In digital printing, Marcus darkened the legs and torso so that the face would be prominent.

posing and lighting, animated expressions, a wide selection of different images to choose from—the parents might say something like, "Wow, that just doesn't look like our little Ralphie." That's because little Ralphie doesn't really look like their mental image of him. Parents have idealized mental images of their kids and when they see them in pictures, they sometimes don't emotionally relate to the child in the photo-graph. What they see in their minds' eye is their perfect child, not necessarily the same child who was just photographed.

That's just one pitfall in the world of children's portraiture. Kids, especially little ones, are easily frightened, so extra care must be taken to provide a safe, comfortable working environment. The photographic experience must, by itself, be fun for the child.

FACING PAGE—Stacy Bratton uses soft, large light—primarily a 72 x 54-inch Chimera softbox with an extra baffle in the middle. She uses it straight on and with the bottom edge parallel to the floor so that the catchlights it produces are square—a unique trademark of her lighting. For hair and background light, she bounces light into a drop ceiling (usually white, but sometimes black or gray Fome-Cor, depending on the desired effect), that is eight feet above the set. **ABOVE**—Stacy Bratton is a whiz at working with kids, but sometimes even the best-laid plans fall short of what's needed. Here, it has become stereo hysteria and the only thing to do is to get a good image. Parents will often appreciate this kind of image of their kids as much as the cute smiling ones.

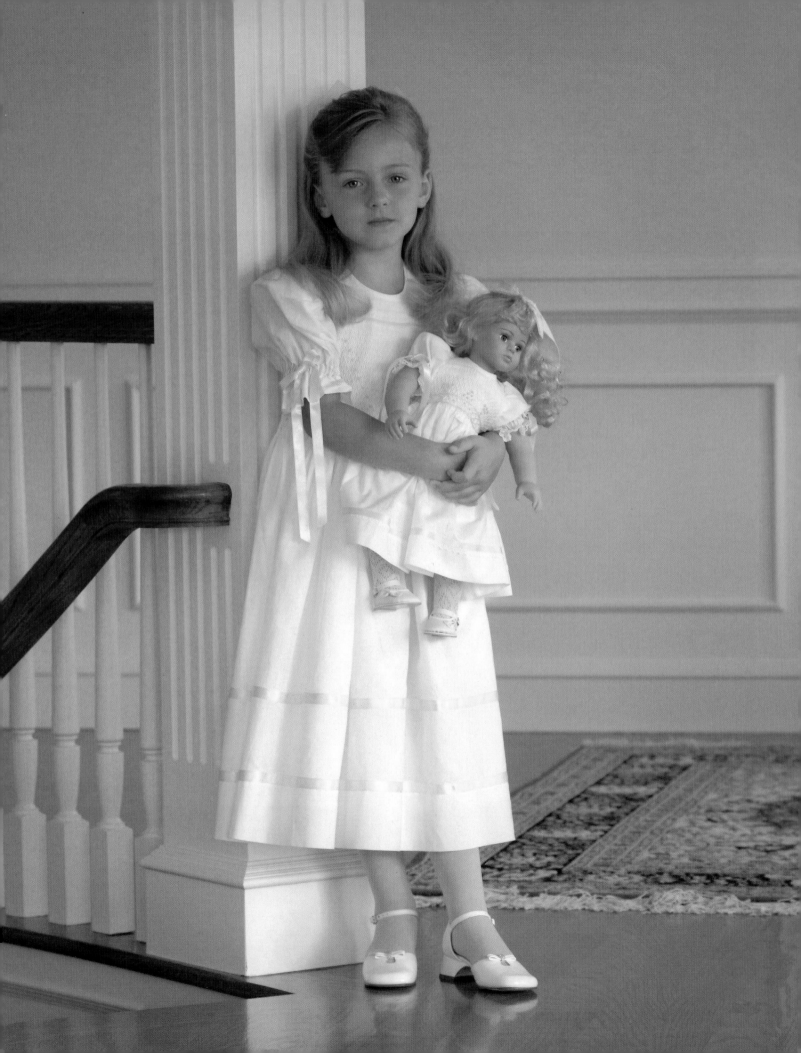

○ THE TEAM APPROACH

Children's portraiture takes an extraordinary amount of timing and teamwork. If you pursue this specialty, you will eventually come to the conclusion that one pair of eyes and hands is not enough—that it takes a team to effectively photograph children. Having the child's mother as part of that team can help. Photo studios can be scary places for little ones—every time a strobe goes off, it is a frightening experience. If Mom is nearby, she can reassure the child. Sometimes, with babies who can't sit upright, someone also has to prop them up until the moment of exposure. Always remember, no matter how great the shot, keep the environment safe for the child.

○ LIGHTING FOR CHILDREN

Diffused light sources are ideal when photographing children. They bathe the subject in light and produce beautiful contouring of the face, but they are also forgiving—if the child moves a half-foot in either direction, the exposure and lighting will remain pretty much the same. Also, a large, diffused key light often doesn't need a separate fill light, since the highlights tend to "wrap around" the contours of the face. If any fill source is needed, a reflector card will usually do the job. (Note: the closer the diffused light source is to the subject, the softer the quality of the light. As the distance between light source and subject increases, the diffused light source becomes more like direct light.) Hair lights, background lights, and kickers (accent lights set from behind the subject) are usually all diffused light sources when you are working with kids. A small softbox, like a striplight, is ideal.

○ SOME FAVORITE SETUPS

Children's portrait photographers often have a favorite basic lighting setup that they use either most of the time (because it works and they like it) or as a starting point (because they're confident in the results).

Brian Shindle uses a big, soft light—usually a 4 x 6-foot unit and a secondary 2 x 4-foot softbox to wash his small clients in a soft directional light. The light is large and forgiving. A big softbox is actually larger than most children. When used at floor level coming from the side, it resembles window light or light coming through an open doorway. It is an excellent illusion—especially if used on location. Other times, Brian will use window light from large banks of windows to create the same effect as large softboxes used close to the subject.

Another popular children's lighting setup is done with a softbox and silver reflector with the child in a profile pose. The softbox is positioned close to and facing the child, not behind the child. You are lighting the frontal planes of the face straight on, but photographing the face from the side so that the light is actually skimming the skin's surface. The light is feathered toward the camera so that the edge of the light is employed. The silver reflector, positioned between the child and the camera, but below camera level, is adjusted until it produces the maximum amount of fill-in. It is important to use a lens shade with this type of lighting, because you are feathering the softbox towards the lens, which can cause lens flare. You can, of course, feather the light away from the lens, towards the background, but this will make the shot more difficult to fill with the reflector.

○ POSING KIDS

Although this is a book about fine portraiture, when it comes to children, there is really no point in going into formal posing rules. They simply don't apply. After all, even if a two-year old could achieve a proper head-and-neck axis, the likelihood of him holding the pose for more than a nanosecond is slim. And since little ones are mostly non-verbal, posing instructions would be completely ineffective. So then, how does one pose children, especially small children?

When photographing small children and babies, you really need to have an assistant and some props handy to attract their attention. Whether the assistant is down at eye level with the child or behind the cam-

FACING PAGE—This image by Brian Shindle was lit by a bank of windows roughly 10 feet from the little girl. A single reflector was used on the shadow side of the girl for fill-in. The image was made digitally with a FujiFilm FinePix S2 Pro and 35–70mm f/2.8 Nikkor lens. The ISO was set to 400 and the exposure was ⅟90 second at f/4.8. Note the matching outfits of the doll and little girl—an effect suggested by the photographer.

era is strictly up to you—whatever works best. Small stuffed animals, small rocking chairs, and carriages are all good props both to keep the attention of the child and to set an appropriate mood. While your assistant is distracting and amusing the child, you can concentrate on other elements of the photograph—the lighting, composition, and background.

With small children or infants, safety is always the first consideration. A child, who cannot sit up by him- or herself, cannot be "propped" up in a chair or left

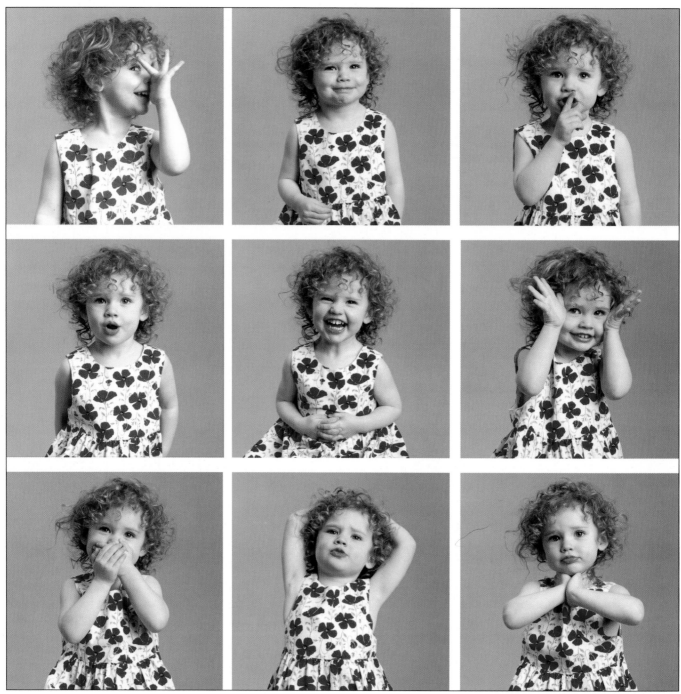

ABOVE—Stacy Bratton photographed this little beauty in an array of moods and poses. Stacy says that her special talent is not taking pictures, although she has extensive training and experience, it's "being able to get a two-year-old who walks in the door, kicks me in the shin and says 'No!' to do everything I'd like them to do, to cooperate fully and hug me and love me—that's my talent." **FACING PAGE**—Children are like sponges, soaking up emotion around them. If there is great love in a family, children in that family will readily show it. Here, Frances Litman captured the love between a sister and her baby brother. It is genuine and real and Frances captured it beautifully.

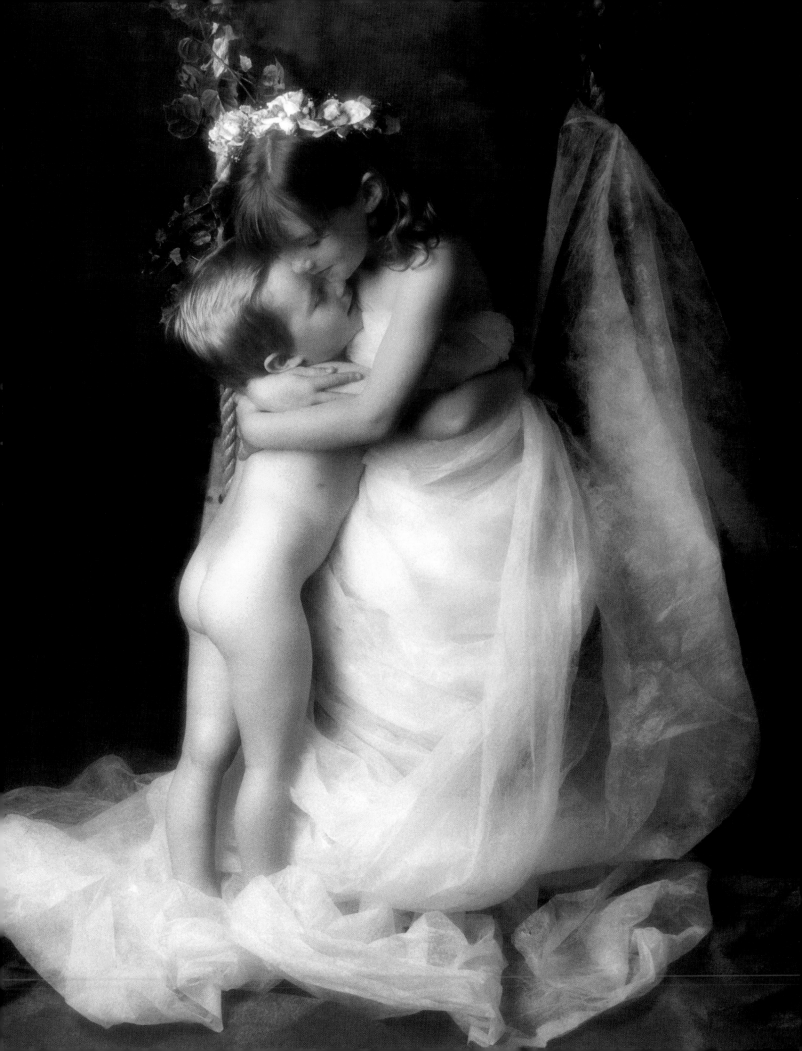

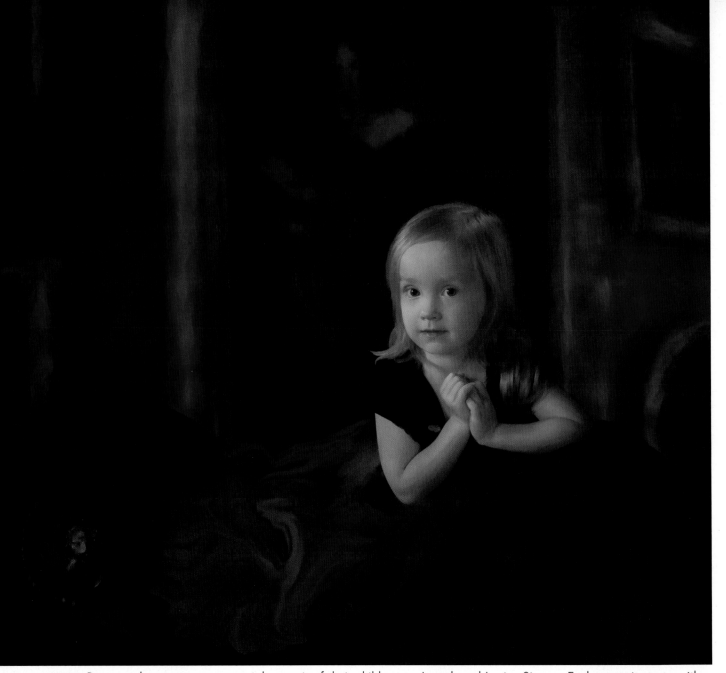

ABOVE—Parents who want a very special portrait of their child go to Joseph and Louise Simone. Each portrait starts with a sketched background by Louise. The background is hand drawn and colored and then projected using a Virtual Backgrounds Scene Machine, a seamless background projection system. The subject is then brought in and lit in the famous Rembrandt light, which is a tradition of the Simones. The image is captured digitally on a Contax 645 camera with digital back and the final portrait is worked by Louise in Painter until the right amount of painting characteristics are rendered. **FACING PAGE**—Stacy Bratton is highly skilled at getting kids relaxed in front of the camera. Here, the expression and pose are priceless. Communication between you and the child is always the key to eliciting great expressions.

alone on posing blocks. The child should be positioned on the floor or ground with pillows or other soft supports nearby. The parent should be close by and the child should never be left unattended. It is important for the camera to be at the same level as the baby so that you can relate to the child on his or her own level. Psychologically, this is important; instead of leering over a small child with strange and unfamiliar equip-

ment and funny looking lights, you are experiencing the world from the child's point of view, making you an equal of sorts.

It is important to let children do what comes naturally. Amuse them, be silly, offer them a toy or something that attracts their attention, but do so with a minimum of direction. Kids will become uncooperative if they feel they are being over-manipulated. Make

ABOVE—Frank Cava moved in close to this little girl and made a beautiful head-and-shoulders portrait of his confident young subject. The image was made by available light and for the final image Frank darkened the edges and corners of the file in Photoshop. The result is that the child's left eye and smile are most prominent in the portrait. This is an award-winning print. **FACING PAGE**—A child's eyes are full of honesty and genuine personality. Little kids are incapable of guile, so what you see reflected in their eyes is true self. Janet Baker Richardson captured this beautiful young girl in a pensive happy moment. Janet wanted only the face and hands sharp so she photographed the girl with the lens wide open, using a relatively fast shutter speed in existing daylight.

a game out of it so that the child is as natural and comfortable as possible. Generate a smile, but don't ask them to smile. You will probably not get what you want.

Even as children get older, the "on the tummy" pose still works well, as kids will rest comfortably with their head on their hands.

As mentioned, it's a very good idea to have Mom nearby—usually just out of frame. Infants will sometimes stay put, but other times they will crawl off and have to be brought back. Having Mom close at hand makes things much easier and gives the baby some reassurance in a strange environment. The presence of a parent also helps the photographer evoke special emotions and expressions. The photographer can say

to the child, "Look at Daddy, isn't he silly?" This is Dad's cue to act goofy or in some way amuse the child.

○ **OVERSTIMULATION**

All children need stimulation in order to get good photogenic expressions. With very young children, you can accomplish this in a number of ways—by talking, imagining (playing make-believe), being silly, making noise, or giving them something to hold on to and play with. With that same level of stimulation, older children (four- and five-year-olds) will end up getting overstimulated—which can make them uncooperative, to say the least. Experience is always the best instructor, but generally more stimulation is required for younger children, because their attention span is so

short. Remember that the end result is to get great expressions, so use your energizing skills wisely.

○ ELICITING EXPRESSIONS

Kids will usually mimic your mood. If you are loud and boisterous, they will be too, assuming they are not shy or quiet by nature. If you're soft-spoken and kind, this too will rub off. If you want a soft, sweet expression, get it by speaking in gentle tones. If you want a big smile, bring the enthusiasm level up a few notches. Above all, be enthusiastic about taking the child's portrait. The more he or she sees how fun and important this is to you, the more seriously the child will take the challenge.

○ THE EYES

A child's eyes reflect all of the qualities that are the essence of childhood. It is imperative that the eyes are a focal point of any children's portrait. Even with adults, the eyes are the primary area of visual interest.

The best way to keep the child's eyes active and alive is to engage him or her in conversation or a game of some type. If the child does not look at you when you are talking, he or she is either uncomfortable or shy. In extreme cases, you should let Mom do all of the enticing. Her voice is soothing and will elicit a positive expression.

The direction the child is looking is important. Start the session by having the child look at you. Using a cable release with the camera tripod-mounted allows you to physically hold the child's gaze.

○ CAMERA HEIGHT

Be aware of perspective and its positive and negative effects when posing children. For a head-and-shoulders portrait, the camera height should be mid-face

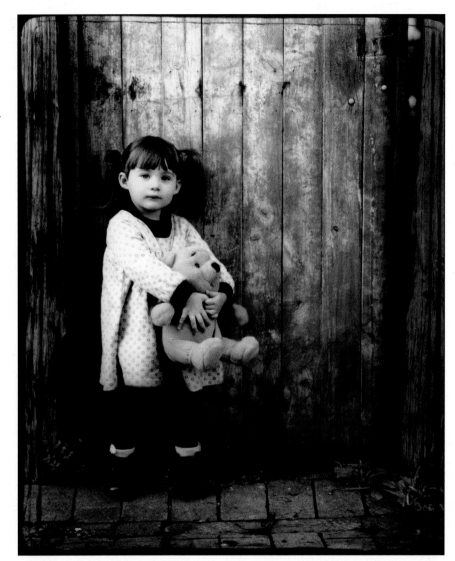

ABOVE—It sounds basic, but you'd be surprised how many children's portraits are made from the adult photographer's standing height. It is important to get down to the level of the child, not only for proper perspective but also so that you can relate to the child on their level. Photograph by Martin Schembri. **FACING PAGE**—Anthony Cava photographed this young girl in an improbable but interesting location. There is great color coordination between the blue of her jeans and the graffiti, and the olive color of her jacket and the stone work behind her. Notice, too, that Anthony had her position her hands in a natural and believable pose.

(nose height). Too high a camera position will narrow the child's cheeks and chin; too low a camera height will distort the shape of their heads. For three-quarter length and full-length poses, the camera height should be midway between the top and bottom of the child's body—especially with shorter focal lengths.

○ HANDS

Children's hands are delicate and beautiful and should be included in their portraits when at all possible.

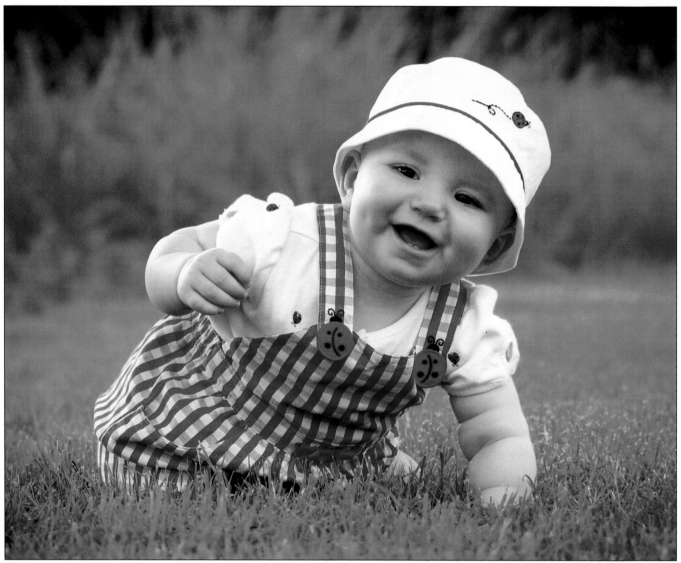

Babies can sometimes just barely support their own weight. This image made by Kevin Jairaj, is a classic. The lighting is soft and delicate—a mixture of soft shade and more powerful reflected light from a handheld reflector to camera left. The expression is priceless. Unlike adults, babies don't mind having arms that make them look like the Michelin man. This image was made with a Sony Cybershot at ⅟₄₀₀ second at f/2.4 at ISO 100 and at the 48mm focal-length setting.

While it is impossible to pose children's hands, other than to give the child something to hold, you can control a few things by varying subject distance and focal length. If using a short focal length lens, for example, the hands will be close to the camera and appear larger than normal. Using a little longer-than-normal focal length means sacrificing the intimacy of working close to the child, but it will correct the perspective. Although holding the focus of both hands and face is more difficult with a longer lens, the size relationship between them will appear more natural. And if the hands are slightly out of focus, it is not as crucial as when the eyes or face are soft.

○ **THREE-QUARTER AND FULL-LENGTH POSES**

When children are concerned, the difference between ¾- and full-length poses is slight. There are a few things you should keep in mind, however.

A ¾-length portrait is one that shows the subject from the head down to a region below the waist. Usually, a ¾-length portrait is best composed by having the bottom of the picture be mid-thigh or below the knee and above the ankles. Never "break" the composition at a joint—at the ankles, knees, or elbows. It is visually disquieting.

A full-length portrait shows the subject from head to toe. This can be in a standing or sitting position, but

it is important to remember to slant the child to the lens or adjust your camera position so that you are photographing the child from a slight angle. The feet, ordinarily, should not be pointing into the lens.

When the child is standing, hands become a real problem. If you are photographing a boy, have him stuff his hands in his pockets—it's an endearing pose.

You can also have him fold his arms, although children sometimes adopt a defiant stance in this pose. With little girls, have her put one hand on her hip, making sure you can see her fingers.

Full-size chairs make ideal props for standing children, because the child's hands can easily be posed on the arm of the chair or along the chair back.

Marcus Bell incorporates a lot of the techniques he uses in his award-winning wedding photography to photograph children. For example, he uses a wide-angle lens close to the subject for an unusual perspective and he uses selective focus to blur all but the facial elements of the portrait. His ability to get unique expressions is amazing.

7. Building Groups

There are a number of ways to look at designing family groups. The first is a technical consideration; you can design your group so that those posed in the back are as close as possible to those in the front. This ensures that your plane of focus will cover the front row as well as the back row. It is a good habit to get into if you want your groups to be sharply focused.

The second consideration in posing groups is aesthetic. You are building a design when creating a group portrait. Norman Phillips likens family-portrait design to a florist arranging flowers. He says, "Sometimes we

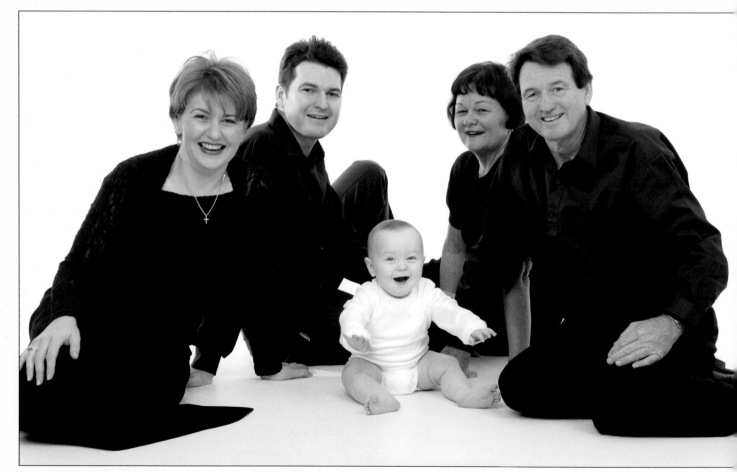

Marcus Bell employed a logical hierarchy in this family portrait of three generations: parents on the right, children on the left and grandchild in the middle. Using a moderate wide-angle lens, Marcus created a modified pyramid shape with an interior triangle shape to help you focus on the baby each time your eye scans the group. The tonal coordination and design are both excellent in this family portrait.

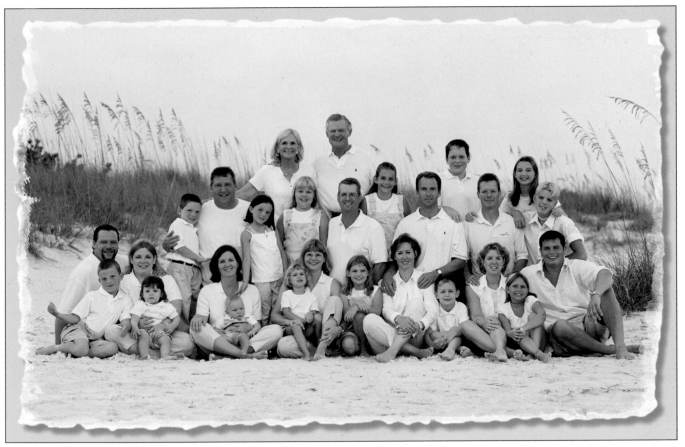

Sometimes, you will want to pose a family using established hierarchies, in this case by family group. The parents are center-most at the top of the triangle. Their kids (plus spouses) are arranged beneath the parents with the grandkids scattered throughout. The little ones, by necessity are pictured in the front row. Notice how the photographer coordinated the outfits to perfection—a popular choice, khaki and white. Photograph by Tibor Imely.

might want a tight bouquet of faces. Other times we might want to arrange our subjects so that the group looks interesting apart from the dynamics of the people in the group." In other words, sometimes the design itself can be what's important.

A third consideration is proximity. How close do you want each member of the group to be? Phillips relates proximity to warmth and distance to elegance. If you open the group up you have a lot more freedom to introduce flowing lines and shapes within the composition of the group. A tightly arranged group where members are touching implies warmth and closeness.

○ **POSING HIERARCHY**

Is it more important to pose by age, importance, or size? This is a point of debate among family-portrait photographers. Some advise photographers to concentrate on organizing the groups and subgroups into logical units. The reasoning is that these subgroups (such

as the oldest son, his wife and two kids) want to be photographed separately at the same session, thus doubling sales. Also, the family is more cohesively arranged if organized by age (grandparents in the middle, with their children adjacent and the grandchildren and their families in the outer or forward realms of the group). One can arrange subjects by size within the subgroups for the most pleasing composition.

Some photographers pose their groups from the center out. In the case of a family group, the grandparents or parents would be right in the middle. Other photographers prefer to pose their groups by defining the perimeters of the group (i.e., the frame edges, left and right), and then filling in the center with interesting groupings.

○ **POSING DIALOGUE**

Act out how you want a person to pose. This is much easier than describing what you want—and it takes less

Deanna Urs created this wonderful portrait of two beautiful sisters. The rule of thumb is not to place heads on the same level. For a dynamic portrait of two, placing the eyes of one subject at the chin height of the other is a good alternative. Deanna hand-colored this image to bring out the subtle eye and lip colors as well as some color in the dresses. Deanna also managed to bring out the personalities of these young ladies in a very sophisticated portrait.

time. Once everyone is in the pose you want, wait for the special moment when they forget all about having their pictures taken. Then it's show time. Always be positive and always be in charge. Once you lose control of a large group it can be difficult or impossible to regain it.

Talk to your subjects and tell them how good they look and that you can feel their special emotion (or whatever dialogue seems appropriate). Let them know that you appreciate them as unique individuals, and so on. If closeness is what you are after, talk them into it. It sounds hokey, but if it does nothing more than relax your subjects, you have done a good thing.

○ PERIMETER CHECK

Once your group is composed—especially when working with larger groups—do a once-around-the-frame analysis, making sure the poses, lighting, and expressions are good, and that nothing needs adjusting. You should not only check each person in the group in the viewfinder, but once that's done check the negative space around each person. Scan the perimeter of each person, checking for obvious flaws and refinements you could quickly make. Now is the time to analyze your image, not after you've made four or five frames. Two quick scans of the viewfinder are all it takes.

When working with smaller groups and working digitally take a moment to show them the playback of the image on the camera's LCD. Sometimes they will have important feedback when they see the portrait.

○ COORDINATING APPAREL

If the group doesn't look unified, the portrait won't look professional. It seems like a simple concept, but

that's not always the case. One noted photographer, who shall remain nameless, says, "They never listen to me no matter how adamant I am about coordinating the clothes. I am constantly amazed at what they show up in."

Some photographers, like Bill McIntosh, are masters of the coordinated environment. Here's what he has to say about planning. "No matter how good your artistic and photographic skills are, there is one more element required to make a great portrait—color harmony." In McIntosh's photographs, the style and color of the clothing all coordinate. He says, "I have ensured these suit both the subjects and the environment chosen." Bill makes sure everything matches. "Time is well spent before the sitting discussing the style of clothing—formal or casual—and then advising clients of particular colors, which they feel happy with and which will also create a harmonious portrait."

Some photographers view clothing harmony as the primary element in the fine family portrait. Clothes

This portrait, like most of Tibor Imely's family portraits, is so well coordinated it's as if the photographer went out and purchased matching clothes for the family. Everything matches and, even better, every expression is great. This is as good as family portraiture gets. Tibor made the image with a Canon EOS 1DS and zoom lens at the 115mm setting. At ISO 250, the image was exposed for ⅟₈₀ second at f/5.6. The photographer could have chosen a faster shutter speed and correspondingly larger aperture, but he needed an aperture of at least f/5.6 to hold all three rows of people in focus. His focus point is on the middle row. He also could have chosen a faster ISO, but wanted to keep the noise down to a minimum knowing a large print would be part of the final sale.

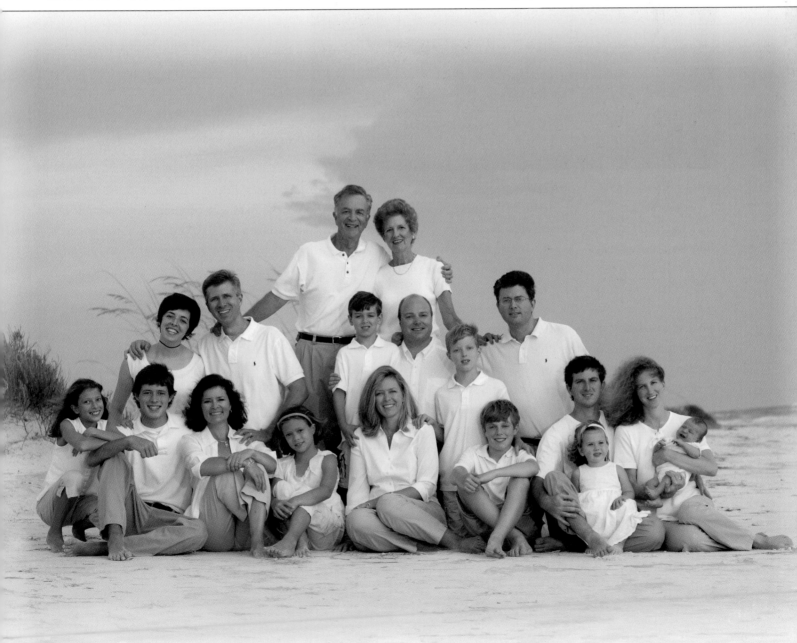

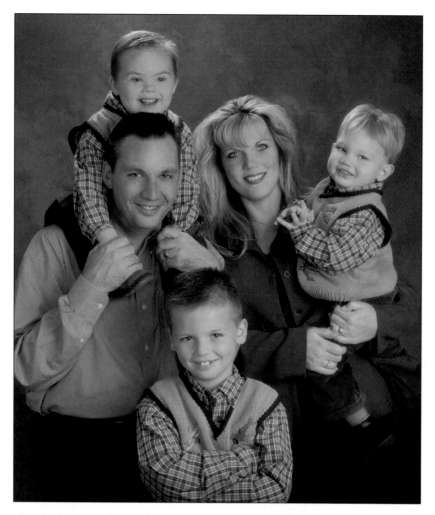

Frank Frost is another great family portrait photographer who is extremely skillful at coordinating apparel. Here the main colors of the outfits are beige, olive green, and brown. The mom and dad are wearing the main colors, while the kids' shirts and sweaters are made up of the same colors. Notice, too, the great posing and the number of lines and shapes found in the composition.

should be coordinated for color, tone, and style. Take, for example, an uncoordinated group where some are wearing short sleeves, some long; some are wearing light-colored pants and skirts, others dark; some have brown shoes, others white; and each person is wearing a different color and pattern. The result will be a cacophony of clothing styles, and you are going to capture an unattractive portrait, regardless of how good the lighting and composition are.

Photographers' Favorites. White is a photographer's favorite clothing color, provided the subjects are of average weight or slender. If your group is on the large side, all that white will make necks and torsos look much larger than they really are. The general rule of thumb is wear white or pastel, you gain ten pounds; wear dark or medium shades and you lose ten pounds.

Solid-colored clothes, in cool or neutral shades, with long sleeves, always look good. Cool colors, such as blue and green, recede, while warm colors, such as red, orange, and yellow, advance. Cool colors or neu-

tral colors (such as black, white, and gray) will emphasize the faces and make them appear warmer and more pleasing in the photographs.

Your group's garments should be complementary. For example, all of the family-group members should wear informal or formal outfits. It's easy when photographing the wedding party when all are dressed identically and formally. Half your battle is won. It is difficult to pose a group when some people are wearing suits and ties and others are wearing jeans and polo shirts. Shoe styles and colors should blend with the rest of a person's attire: dark outfits call for dark shoes and socks.

Robert Love boils it down to this: "[Lack of] color coordination is the main reason that people do not like their previous family portraits." In his pre-session consultation, he talks about color coordination and recommends solid colors, long sleeves, and V-necks for the most flattering portraits.

○ SEATING

Once you begin adding people to a group, one of your preeminent props will be the stuffed armchair, small sofa, or love seat. Its wide arms and often attractively upholstered surface is ideal for supporting additional group members.

An armchair is usually positioned at about 30 to 45 degrees to the camera. Regardless of who will occupy the seat, they should be seated at an angle to the camera. They should be seated on the edge of the seat cushion, so that all of their weight does not rest on the chair back. This promotes good posture and slims the lines of the waist and hips for both men and women.

Note, however, that you will more than likely have to straighten out seated men's jackets and ask the women to straighten the line of their dresses, as sitting normally causes dresses and coats to ride up and bunch.

Here's how Monte Zucker uses an armchair to build a group of almost any size. A woman sits with the upper part of her legs following in the direction that her body is facing. Her legs are then bent back and her ankles crossed. A man sits similarly, except that his feet aren't crossed. The foot closest to the camera is pointed generally toward the lens, while the other foot is positioned at almost a right angle to the front foot.

For a group of two, you can seat one person and either stand the second person facing the chair (for a full-length picture), or seat the second person on the arm of the chair, facing inward toward the person seated in the chair. The body of the person seated in the chair should be in front of the person seated on the arm.

When adding a third person to the group, you can either seat the person on the second arm or stand the person. That person should have his/her weight on their back foot, thereby lowering the back shoulder. All three heads should be equidistant.

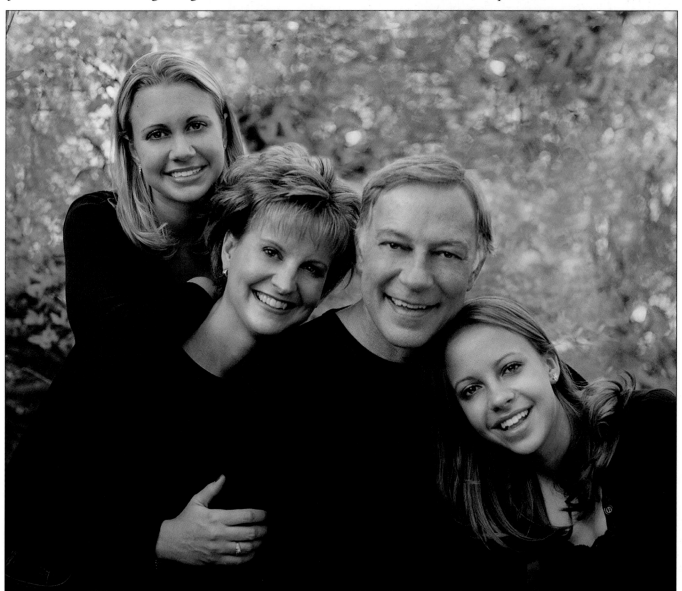

Frank Frost has used a fence instead of an armchair as his primary posing tool. Dad is firmly planted, while Mom is partially standing with one foot on the ground. The daughters are standing. Frank designed the pose to create a meandering horizontal line. The family's heads are reminiscent of musical notes on a score. The tilt of each head is different, making the portrait even more visually enjoyable. The background has been lightened and made more pastel-colored to reflect the lighthearted mood of the family.

Here is the armchair pose working to perfection. Mom is seated with Dad sitting on the armrest, which raises his head height. Mom and Dad tilt their heads in toward each other. The daughter stands behind the group, her face filling in the top of the perfect triangle shape. The photographer vignetted the bottom portion of the portrait in Photoshop, so that the image details fade to black. Photograph by Frank Frost.

A group of four has two people seated in chairs, and one person seated on the outermost arm, facing inward toward the center of the group. The fourth person is standing, facing toward the center of the group. The person seated on the arm of the chair has his arm coming straight down behind the person seated slightly in front of him. In all groups, there should be equal distance between each of the heads. Do not have two heads close together, while the others are spaced farther apart. It destroys the rhythm of the group.

If there is a heavy person, put that person behind someone, so that you are covering some of his or her body. Make certain that all the people seated on the arms are situated slightly farther from the lens than the people seated in the chairs.

From here on, it's just a question of adding faces where they need to be to continue the flow of the composition. You can fit someone squatted down in the middle of the group, covering a lot of legs. You can have people kneel down on either side of the group as well as seated on the ground, completing the pyramid composition. This little group can easily become a group of fourteen. Just follow the rhythm throughout the group. Look for the triangles between heads, diagonal lines, and equal spacing between all of the people.

○ ARRANGING SMALL GROUPS

Start with Two. The simplest of groups is two people. Whether the group is a brother and sister, or grandma and grandpa, the basic building blocks call for one per-

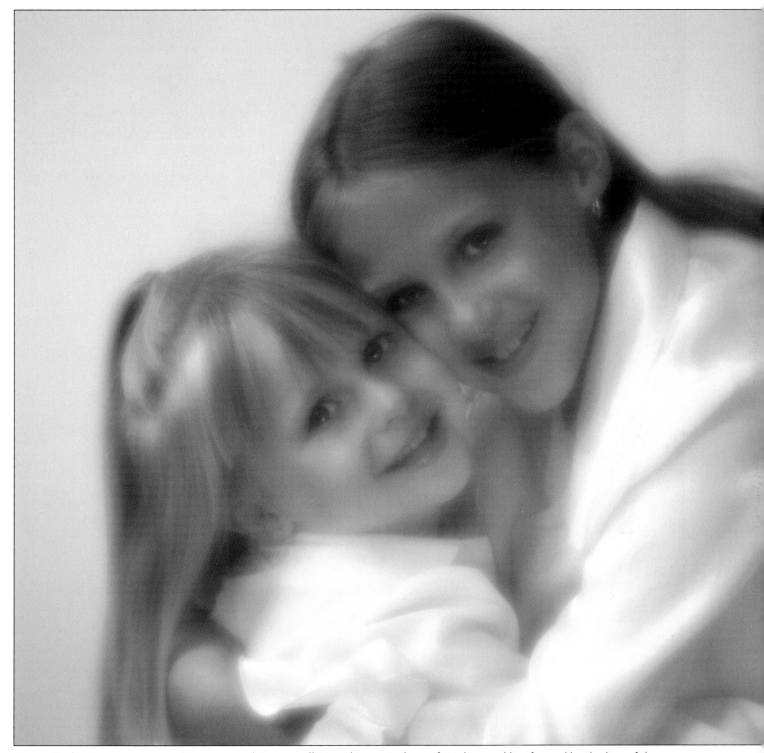

Monte Zucker is a master at creating groups, big or small. Here, he created a perfect diagonal line formed by the line of the eyes of the two sisters. He had the sisters embrace to bring their heads even closer and he then said the magic words that made the frame light up. Monte made this image with a Canon EOS 1DS, EF 250mm Soft Focus lens at 1/250 second at f/2.8 at a film speed of ISO 400.

son slightly higher than the other. Generally speaking, the mouth height of the higher subject should be at the forehead height of the lower subject. Many photographers recommend mouth to eyes as the ideal starting point. Also, since this type of image will be fairly close up, you will want to make sure that the frontal planes of their faces are roughly parallel so that you can hold the focus in both faces.

Here's a variation on the armchair treatment. Obviously, these two sisters are too small to use the chair as adults would for posing, so the photographer posed them shoulder to shoulder and turned away from each other, using the chair as a background. The result is effective and charming. Photograph by Deborah Ferro.

Although they can be posed in a parallel position, each with their shoulders and heads turned the same direction—as one might do with twins, for example—a more interesting dynamic can be achieved by having the two subjects pose at 45-degree angles to each other so their shoulders face in toward one another. With this pose you can create a number of variations by moving them closer or farther apart.

Add a Third. A group portrait of three is still small and intimate. It lends itself to a pyramid- or diamond-shaped composition, or an inverted triangle, all of which are pleasing to the eye.

Don't simply adjust the height of the faces so that each is at a different level. Use the turn of the shoulders of those at either end of the group as a means of linking the group together.

Once you add a third person, you will begin to notice the interplay of lines and shapes inherent in good group design. As an exercise, plot the implied line that goes through the shoulders or faces of the three people in the group. If the line is sharp or jagged, try adjusting the composition so that the line is more flowing, with gentler angles. Try a simple maneuver like turning the last or lowest person in the group inward toward the group and see what effect it has.

Still as part of the exercise, try a different configuration. For example, create a single diagonal line with the faces at different heights and all people in the group touching. It's a simple yet very pleasing design. The power and serenity of a well defined diagonal line in a composition can compel the viewer to keep looking at the portrait. Adjust the group again by having those at the ends of the diagonal tilt their heads slightly in toward the center person. It's a slight adjustment that can make a big difference in the overall design of the image.

How about trying the bird's-eye view? Cluster the group of three together, grab a stepladder or other high vantage point, and you've got a lovely variation on the three-person group—what Norman Phillips calls the bouquet.

One of Monte Zucker's favorite strategies for three-person groups at wedding receptions is to have one person seated with two people standing behind, leaning down so that their heads are close to the seated person's head. It's a shot he can make quickly, and all the faces are in the same plane, so sharp focus is easily attained.

When you add a third person to the group, hands and legs start to become a problem. One solution is to

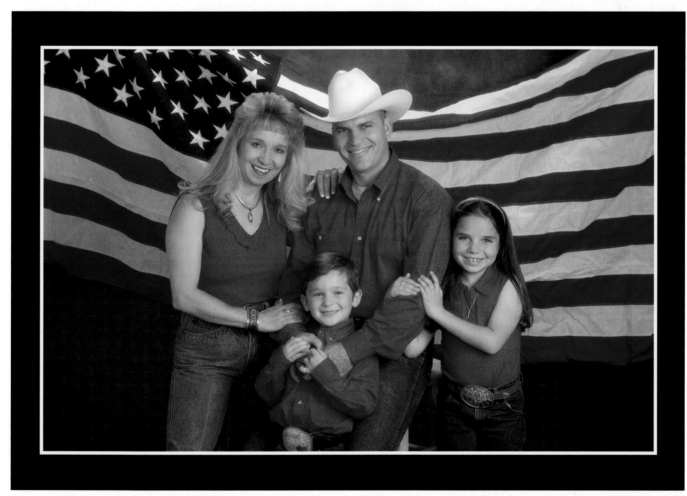

Even numbered groups are much harder to pose than odd-numbered groups. Here Frank Frost created a symmetrical diamond-shaped pose, which, under most circumstances, would be too repetitive. However, because the long horizontal of the draped flag is the background, the combination of the symmetrical and asymmetrical shapes creates a good balance to the composition. Also, note the quality of the expressions.

This family of four was arranged in an S-curve composition, which gives the pose an asymmetrical look—perfect for an even-numbered group. Notice the expert color coordination and the contrast with the New Mexico Fall foliage. Photograph by Frank Frost.

show only one arm and leg per person. This is sage advice when, especially when the family is similarly dressed, one is not always sure whose hand belongs to whom. Generally, the outer hand should be visible, the inner hand, compositionally, can be easily hidden.

Groups of three and more allow the photographer to draw on more of the available elements of design, in addition to the design elements of the group itself. The accomplished family photographer will incorporate architectural components or natural elements, such as hills, trees, shrubs, flowers, gates, archways, furniture, etc.

As you add more people to a group, remember to do everything you can to keep the film plane parallel to the plane of the group to ensure everyone in the photograph is sharply focused.

Adding a Fourth. With four subjects, things get interesting. You will find that as you photograph more group portraits even numbers of people are harder to pose than odd. Three, five, seven, or nine people are much easier to photograph than the even-numbered group of people. The reason is that the eye and brain tend to accept the disorder of odd-numbered objects more readily than even-numbered objects. According

to Norman Phillips, even numbers don't work as well because they make diagonals too long and they leave an extra person to find space for in traditional triangular compositions. As you will see, the fourth member of a group can become an "extra wheel" if not handled properly.

With four people, you can simply add a person to the existing poses of three described above, with the following caveat: be sure to keep the eye height of the fourth person different from any of the others in the group. Also, be aware that you are now forming shapes within your composition. Try to think in terms of pyramids, inverted triangles, diamonds, and curved lines.

The various body parts—for instance, the line up one arm, through the shoulders of several people, and down the arm of the person on the far side of the group—form an implied line that is just as important as the shapes you define with faces. Be aware of both line and shape, and direction, as you build your groups.

An excellent pose for a family of four is the sweeping curve of three people with the fourth person added below and between the first and second person in the group.

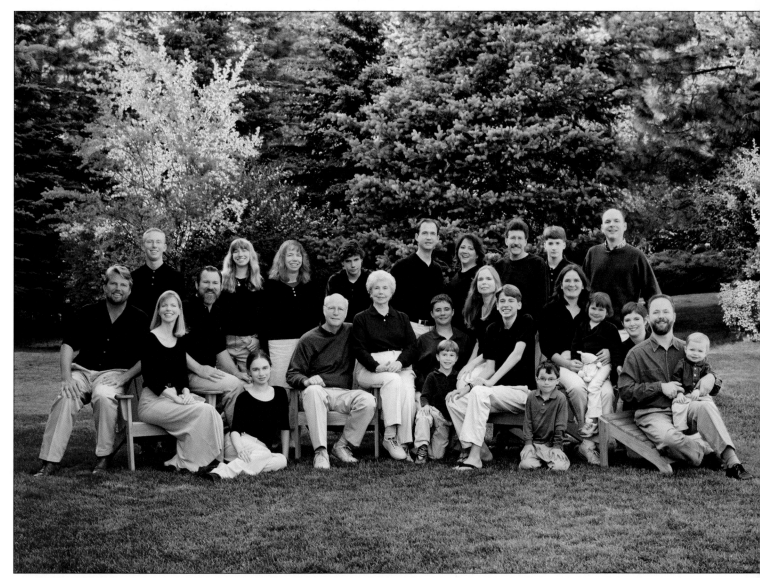

This is a remarkable application of the armchair posing scenario carried out by photographers Robert and Suzanne Love. Here 25 people are posed on and around three armchairs and one footrest. The Loves used a definite posing hierarchy here with the grandparents in the middle and the children, grandchildren and great-grandchildren composed by family unit around the grandparents. Notice the different angles of each member of the group. Each is carefully and naturally posed and everyone's expression is pleasant. The Loves have a motto that each person in a group should look great.

Parker Pfister captured this beautiful group portrait of three angels with a Nikon D1X and 85mm f/1.4 lens. The image was shot at f/2.7, leaving only the faces sharp. The photographer added noise and blurred the portrait in Photoshop, particularly the background, so that only the faces remain sharp.

If you find that one of the subjects in your group is not dressed the same as the others (this happens more than you would imagine), he or she can be positioned slightly outside the group for accent, without necessarily disrupting the color harmony of the rest of the group (see page 78).

When Monte Zucker has to pose four people, he sometimes prefers to play off of the symmetry of the even number of people. He'll break the rules and he'll seat two and stand two and, with heads close together, make the line of the eyes of the two people parallel with the eyes of the bottom subjects.

When two of the four are little people, they can be "draped" to either side of the adults to form one of the pleasing traditional shapes.

Five on Up. Remember that the composition will always look better if the base is wider than the top, so the final person added should elongate the bottom of the group.

Remember too that each implied line and shape in the photograph should be designed by you and should be intentional. If it isn't logical—i.e., the line or shape doesn't make sense visually—then move people around and start again. The viewer's eye should not just meander through the image but should be guided by the lines and shapes you create within the composition.

Try to coax S shapes and Z shapes out of your compositions. They form the most pleasing shapes and will hold a viewer's eye within the borders of the print.

Remember that the diagonal line has a great deal of visual power in an image and is one of the most potent design tools at your disposal.

Always remember that the use of different levels creates a sense of visual interest and lets the viewer's eye bounce from one face to another (as long as there is a logical and pleasing flow to the arrangement). The placement of faces, not bodies, dictates how pleasing and effective a composition will be.

When adding a sixth or an eighth person to the group, the group still must look asymmetrical for best effect. This is best accomplished by elongating sweeping lines and using the increased space to slot extra

people. Keep in mind that while a triangle shape normally calls for three people, you can add a fourth subject and keep the shape intact.

As your groups get bigger, keep your depth of field under control. Use the tricks described earlier (like raising the camera to keep it parallel to the group or leaning the last row in and the front row back slightly to create a shallower subject plane).

As you add people to the group beyond six, you should start to base the shapes within the composition on linked shapes, like linked circles or triangles. What makes the combined shapes work is to turn them toward the center—the diamond shape of four on the left can be turned 20 degrees or less toward center, the diamond shape of four on the right (which may encompass the center person from the other group) can also be turned toward the center.

○ OBVIOUS THINGS TO AVOID

One of the biggest flaws a portrait photographer can create in an image is a background element that seemingly "sprouts" from one of the subjects. The telephone pole comes to mind as a classic example. While this is an amateur mistake for the most part, the truth is that even award-winning pros make this same mistake when they fail to do a final perimeter check. Be sure to scan the group's silhouette, making sure there's nothing in the background that you missed. Pay particular attention to strong verticals, like light-colored posts or columns, and also diagonals. Even though

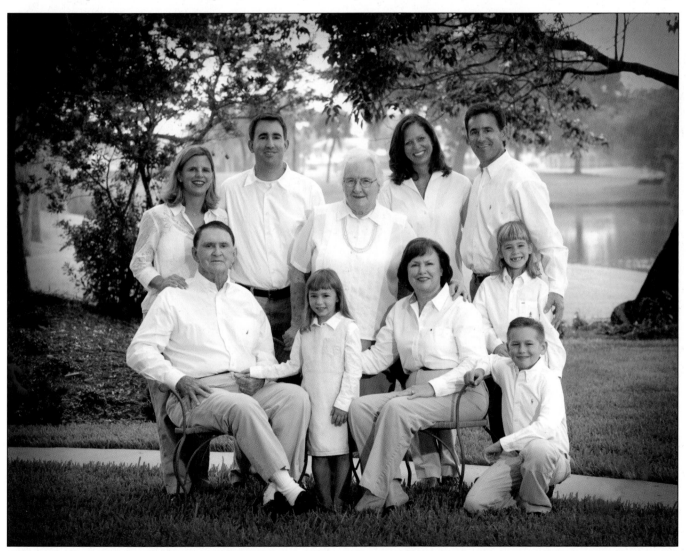

Tibor Imely pictured four generations in one family portrait. He used three different levels of posing to do it. Standing, sitting, and a modified short kneel. Tibor used a Canon EOS 1DS, 105mm lens and fill-flash to get the shot. The exposure was ¹/₁₀₀ second at f/5.6.

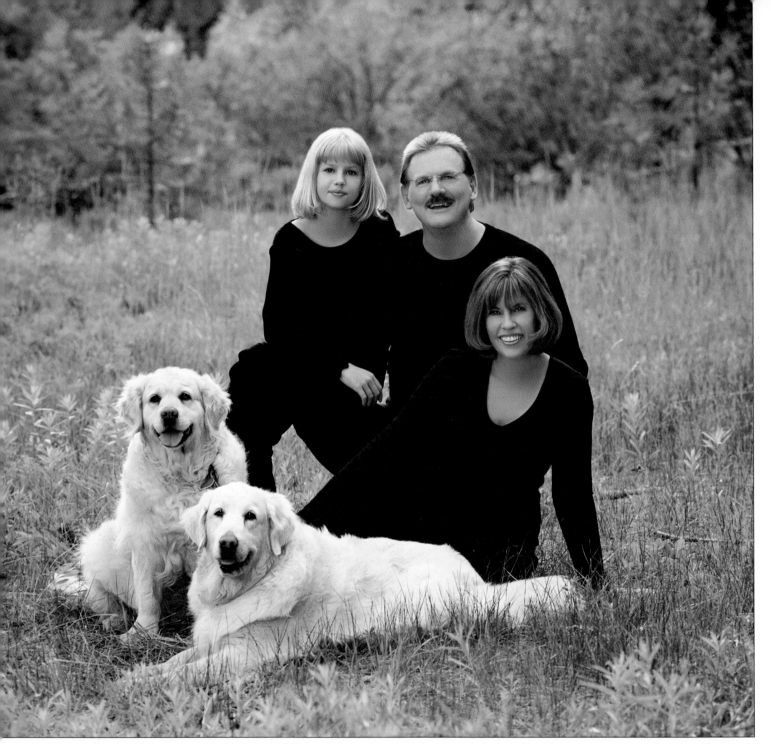

Robert and Suzanne Love used three different levels of posing to position the head heights at appropriate distances from one another. The sitting pose of the woman forms the base of the posing triangle. The modified kneeling/sitting pose of the man gets him up higher than the woman, and you can see the direction and shape of the group taking place. The daughter is sitting on her dad's knee in close proximity to her dad's face.

these elements may be out of focus, if they are tonally dominant they will disrupt and often ruin an otherwise beautiful composition.

One way to control your background more effectively is to scout the locations you want to use before you show up to make the portrait. Check the light at the right time of day and be prepared for what the changing light might do to your background an hour or two later.

○ REALLY LARGE GROUPS

Once a group exceeds nine people, it is no longer a small group. The complexities of posing and lighting expand and, if you're not careful to stay in charge,

chaos will reign. It is always best to have a game plan in mind with big groups.

Posing bigger groups requires you to use standing poses, often combined with sitting and kneeling poses. Those subjects who are standing should be turned at least 20 degrees off center so that their shoulders are not parallel to the film plane. The exception is with small children, who gain visual prominence when they are square to the camera.

With standing poses, care must be taken to disguise wide hips and torsos, which can sometimes be accomplished simply by using other people in the group. Always create space between the arms and torso simply by placing a hand on a hip or, in the case of men, placing a hand in a pocket (thumb out).

In really large groups, the task of clothing coordination can be a nightmare. It is often best to divide the group into subgroups—family units, for instance—and have them coordinate with each other. For example, a family in khaki pants and yellow sweaters could be positioned next to a family in blue jeans and red sweaters.

For really big groups, it is a good idea to have the subjects stand close together—touching. This minimizes the space between people and allows you to get a larger head size for each person. One directive you must give to the group is that they must be able to see the camera with both eyes. This will ensure that you see all of their faces and that none will be hiding behind the person in front of them.

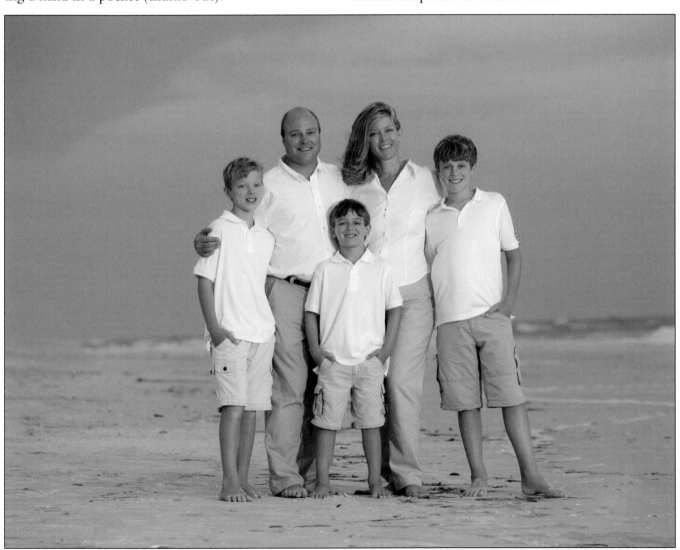

This is a fairly straightforward pose by Tibor Imely. Yet, when we talk about a series of shapes unifying a composition and making it more visually interesting, re-evaluate the pose. How many shapes, triangles, rectangles, and diamonds can you find in the composition? I find eight distinct shapes.

With big groups, fight the tendency to "line 'em up and shoot " This is, after all, a portrait and not a team photo. You can incorporate all types of design elements into even the largest groups.

Naturalness Counts. It is important with medium to large-size family groups that the poses you put your subjects in appear to be natural and comfortable. Even experienced group photographers working with assistants will take ten minutes or so to set up a group of twenty or more. Therefore, it is imperative that your subjects be posed comfortably. Natural poses, ones that your subjects might fall into without prompting, are best and can be held indefinitely.

It is important that the group remains alert and in tune with your efforts. With large groups, it is important to stay in charge of the posing. The loudest voice—the one that people are listening to—should be yours, although by no means should you be yelling. Instead, be assertive and positive and act in control.

With natural poses, have your antennae up for errant thumbs and hands that will pop up. Always do a perimeter search around each subject to make sure there is nothing unexpected in the posing.

Posing Levels. Two true experts at posing the mid-size to large group are Robert and Suzanne Love. I have witnessed them build groups made up of photographers attending one of their workshops and each person, without exception, was amazed when they saw how easy the Loves' technique is and how attractive the arrangement turned out. The basic principle in the Loves' technique is the use of different posing levels and the combinations of those levels used adjacent to one another. Here's a brief look at the system.

Level 1, Standing. Each standing subject has his or her weight on their back foot and is posed at a 45-degree angle to the camera, lowering the rear shoulder to diminish overall body size.

Level 2, Tall Kneel. Generally a masculine pose, not unlike a football players' team pose, this pose calls for the man to get down on one knee with his other leg bent at 90 degrees. The elbow of the arm on the same side as the knee that is up should rest on the knee.

Level 3, Short Kneel. This is the same pose as above but both knees are on the ground and the person's weight is back on their calves. This pose is good for

either men or women, but with women in dresses, they are usually turned at a 45-degree angle.

Level 4, Sitting. The man sits on his buttocks with the leg that is toward the camera curled under the leg that's away from the camera. The elbow rests across his raised knee. For a woman wearing slacks, this is appropriate. However, a more graceful seated pose is achieved when she lays on her hip and rolls slightly toward the camera. Her legs then flow out to the side with the ankles crossed. Her top hand can rest on her lower thigh or in front of her. If she can bring her top knee over to touch the ground, her body produces a beautiful curved line.

Level 5, Lying Down. The subjects can lay on their sides with their hands resting on the sides of their faces, or can lay on their stomachs with their arms folded in front of them. This really works better for an individual pose, rather than a group, but it offers another level if needed.

By intermixing the levels without defining rows, you can pose ten to twenty people quite easily and informally. Each face is at a different level and no face is directly below or above another, providing good visual interest. And while the group is really quite highly structured, it doesn't appear that way.

Stepladders. A stepladder is a must for large groups and, in fact, should be a permanent tool in your wedding and portrait arsenal. Stepladders give you the high angle that lets you fit lots of people together in a tight group, like a bouquet of flowers. Ladders also give you a means to correct low shooting angles, which distort perspective. The tendency is to overuse them, so use a stepladder when you need to or when you want to offer variety in your groups.

A stepladder is the answer to the refrain, "Boy, I sure wish I could get up on that balcony for this shot." But a few words of caution: have your assistant or someone strong hold on to the ladder in case the ground gives or you lean the wrong way. Safety first.

In less dramatic ways, a stepladder lets you raise the camera height just slightly so that you can keep the group plane parallel to the film plane for better depth-of-field control.

Linking Shapes. The bigger the group, the more you must depend on your basic elements of group por-

The overlapping circles around these shapes define each pattern as unique, even though both shapes use the same person centrally. In a portrait like this, each subset should be turned in toward the center to unify the composition, or turned away from center to create a bookend effect.

trait design—circles, triangles, inverted triangles, diagonals, and diamond shapes. You must also really work to highlight and accentuate lines, real and implied, throughout the group. If you lined people up in a row, you would have a very uninteresting "team photo," a concept that is the antithesis of fine family portraiture.

The best way to previsualize this effect is to form subgroups as you start grouping people. For example, how about a family of three here (perhaps forming an inverted triangle), three sisters over on the right (perhaps forming a flowing diagonal line), a brother, a sister and their two kids (perhaps in a diamond shape with the littlest one standing between her mom and dad). Then combine the subsets, linking the line of an arm with the line of a dress. Leave a little space between these subgroups, so that the design shapes you've formed don't become too compressed. Let the subgroups flow from one to the next and then analyze the group as a whole to see what you've created.

Remember that arms and hands help complete the composition by creating motion and dynamic lines that can and should lead up into the subjects' faces. Hands and arms can "finish" lines started by the basic shape of the group.

Be aware of intersecting lines that flow through the design. As mentioned earlier, the diagonal is by far the most compelling visual line in compositions and can be used repeatedly without fear of overuse. Diagram concepts courtesy of Norman Phillips.

Just because you might form a triangle or a diamond shape with one subset in a group does not mean that one of the people in that group cannot be used as an integral part of another group. You might find, for example, that the person in the middle of a group of seven unites two diamond shapes. The overlapping circles around these shapes (see diagram above) define each pattern as unique, even though both shapes use the same person. In a portrait like this, each subset could be turned slightly toward the center to unify the composition or turned away from the center to give a bookend effect.

Be aware of intersecting lines that flow through the design. As mentioned earlier, the diagonal is by far the most compelling visual line and can be used repeatedly without fear of overuse. The curving diagonal is even more pleasing and can be mixed with sharper diagonals within the composition.

8. Outdoor Lighting

Family groups may be photographed in open sunlight or open shade. They may be back lit, side lit, or front lit. What is more important than the direction of the light is the evenness of the light. As Robert Love says, the secret to a great family portrait is to "light them evenly from left to right and from front to back." Good outdoor lighting is primarily what separates the good family-portrait photographers from the truly great ones. Learning to control, predict, and alter daylight to suit the needs of the

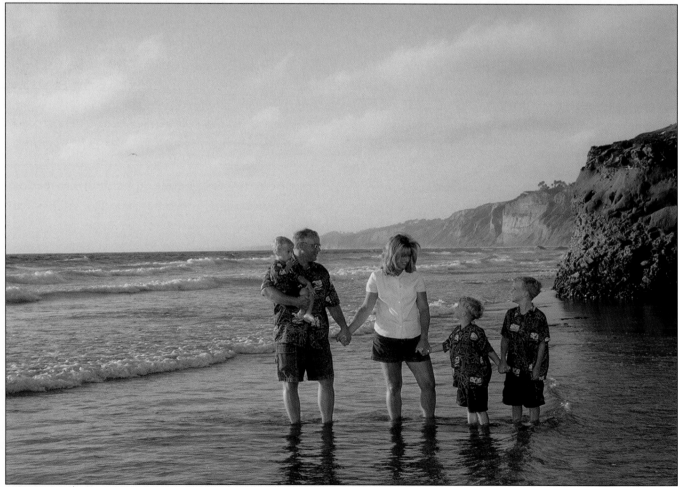

The hazy sunshine at the beach in California is often not as contrasty as ordinary bright sunlight. The haze diffuses the light and cuts down the lighting ratio, in this case producing around a 3.5:1 ratio. Knowing the qualities of light and the existing ratios helps you determine how to light and expose your image. This family portrait by Frank Frost was exposed with a bias toward the shadows, allowing the highlights to overexpose slightly.

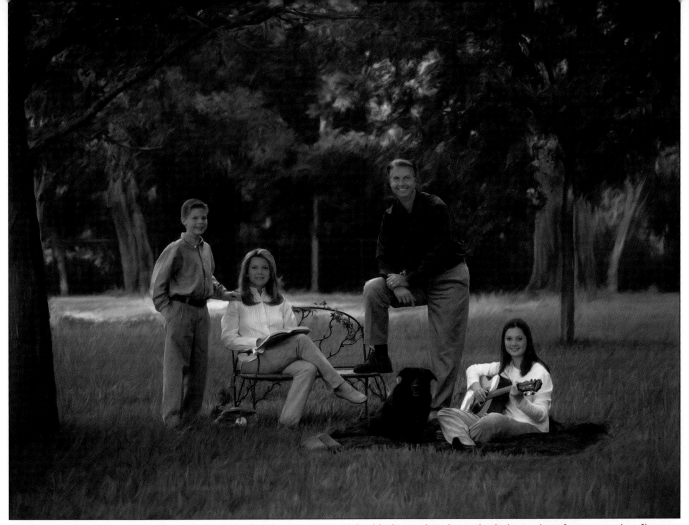

Here, you see light coming in from behind the family, creating nice highlights in their hair. The light on their faces is rather flat—in fact, very close to a 2:1 ratio. The catchlights have been added in Painter. You can see varying lighting ratios in the scene, but none is greater than 2:1. Photograph by Fran Reisner.

group to be photographed is the ultimate objective of the family-portrait photographer.

○ ROUNDNESS

The human face is sculpted and round. It is the job of a portrait photographer to show the contours of the human face. This is done primarily with highlights and shadows. Highlights are areas that are illuminated by the main light source; shadows are areas that are not. The interplay of highlight and shadow creates roundness and shows form. Just as a sculptor models clay to create the illusion of form, so light models the shape of the face to give it dimension.

○ LIGHTING RATIOS

The term "lighting ratio" is used to describe the difference in intensity between the shadow and highlight side of the face. It is expressed numerically. A 3:1 ratio, for example, means that the highlight side of the face

has three units of light falling on it, while the shadow side has only one unit of light falling on it. That's all the lighting ratio means.

Ratios are useful because they determine how much local contrast there will be in the portrait. They do not determine the overall contrast of the scene; rather, lighting ratios determine how much contrast you will give to the lighting of the subject(s). (Note: In the descriptions that follow, the key light refers to the main light source(s). The fill light refers to the source(s) of illumination that fills in the shadows created by the key light. In outdoor lighting situations, the key light can either be daylight or artificial light, such as that from an electronic flash or reflector. The fill light outdoors can also be either daylight or flash.)

Since lighting ratios reflect the difference in intensity between the key light and the fill light, the ratio is an indication of how much shadow detail you will have in the final portrait. Since the fill light controls the

degree to which the shadows are illuminated, it is important to keep the lighting ratio fairly constant. A desirable ratio for outdoor family portraits is 3:1 because it is ideal for average shaped faces.

Determining Lighting Ratios. There is considerable confusion over the calculation of lighting ratios. This is because you have two systems at work, one arithmetical and one logarithmic. F-stops are in themselves a ratio between the size of the lens aperture and the focal length of the lens, which is why they are expressed as f/2.8, for example. The difference between one f-stop and the next full f-stop is either half the light or double the light. F/8 lets in twice as much light through a lens as f/11 and half as much light as f/5.6.

However, when we talk about light ratios, each full stop is equal to two units of light. Therefore, each half

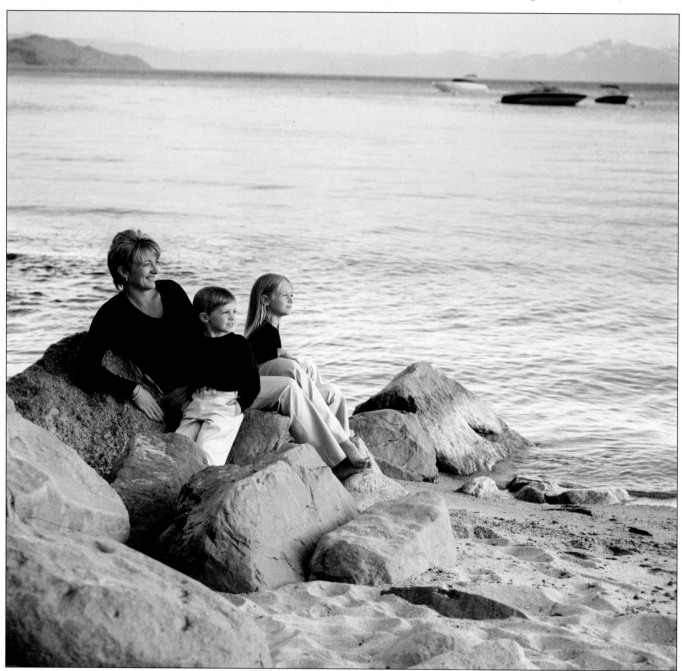

The setting sun at Lake Tahoe, Nevada, is a little different than other places since, at 6000 feet, the sun just sort of dips behind a mountain. However, after the sun does this, the light is still strong and directional—but you can look at the sky and not squint, as is seen here in this portrait by Robert Love. The lighting ratio is about a 3:1 with no additional fill needed because of the wraparound nature of the light and because of the light-colored rocks, which are acting as fill.

stop is equal to one unit of light, and each quarter stop is equivalent to half a unit of light. This is, by necessity, arbitrary, but it makes the light ratio system explainable and repeatable. In other words, it is a practical system for determining the difference between the highlight and shadow sides of the face.

Further, most seasoned photographers have come to recognize the subtle differences between lighting ratios and will strive to reproduce such subtleties in their exposures. For instance, a photographer might recognize that with a given width of face, a 2:1 ratio does not provide enough dimension and a 4:1 ratio is too dramatic, thus he or she would strive for a 3:1 ratio. The differences between ratios are easy to observe with practice, as are the differences between fractional ratios like 3.5:1 or 4.5:1, which are reproduced by reducing or increasing the fill light amount in quarter-stop increments.

In lighting of all types, from portraits made in the sunlight to portraits made in the studio, the fill light is always calculated as one unit of light because it strikes both the highlight and shadow sides of the face. The amount of light from the key light, which strikes only the highlight side of

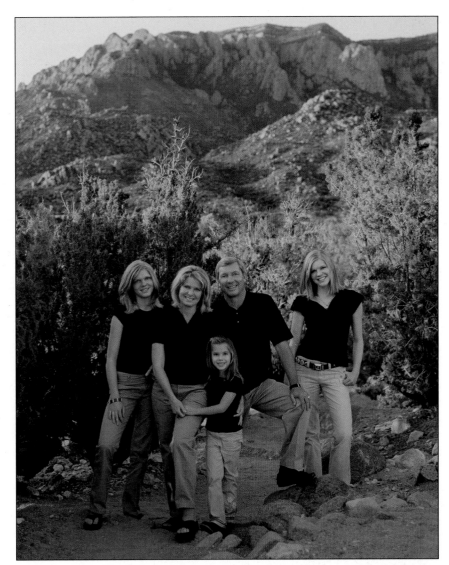

Working at the edge of the light is the technique Frank Frost employed for this family portrait. The sun would have backlit the group, but the foliage on the path blocks it. Instead, the backlighting provides a soft hairlight on each member of the group. The fill light is natural, coming from the sky and the gravel and rocks behind the photographer. Exposure is necessarily biased towards the shadows, making the highlights a little hotter than normal.

the face, is added to that number. For example, imagine you are photographing a small group of three and the main light is one stop greater than the fill light. These two lights are metered independently and separately. The one unit of the fill (because it illuminates both the shadow and highlight sides of the faces) is added to the two units of the key light, which only light the highlight side of the face, thus producing a 3:1 ratio.

Lighting Ratios and Their Unique Personalities. A 2:1 ratio is the lowest lighting ratio you should employ. It shows only minimal roundness in the face

and is most desirable for high key-effects. High-key portraits are those with low lighting ratios, light tones, and usually a light background. In a 2:1 lighting ratio, the key and fill light sources are the same intensity. One unit of light falls on the shadow and highlight sides of the face from the fill light, while an additional unit of light falls on the highlight side of the face from the key light—1+1=2:1. A 2:1 ratio will widen a narrow face and provide a flat rendering that lacks dimension.

A 3:1 lighting ratio is produced when the key light is one stop greater in intensity than the fill light. One

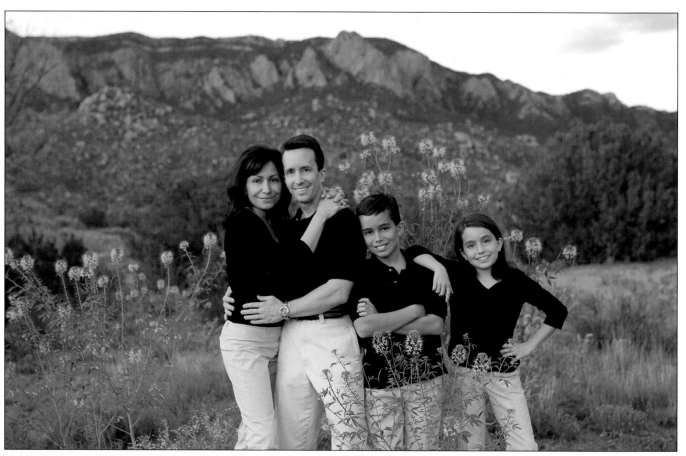

The light of twilight has direction and is very soft—like a huge softbox in the sky. This is the light that Frank Frost likes to use on his location family portraits. Although the light diminishes quickly after sunset, and you have to be aware that it is changing every few minutes, this sweet light is unparalleled for 10 to 15 minutes after sunset. This exposure, made with a Canon EOS-1D Mark II was made at 1/50 second at f/3.4 at ISO 400—not much margin for error.

unit of light falls on both sides of the face from the fill light, and two additional units of light fall on the highlight side of the face from the key light—2+1=3:1. This ratio is the most preferred for color and black & white because it will yield an exposure with excellent shadow and highlight detail. It shows good roundness in the face and is ideal for rendering average-shaped faces.

A 4:1 ratio (the key light is 1½ stops greater in intensity than the fill light—3+1=4:1) is used when a slimming or dramatic effect is desired. In this ratio, the shadow side of the face loses its slight glow and the accent of the portrait becomes the highlights. Ratios of 4:1 and higher are appropriate for low-key portraits, which are characterized by dark tones and, usually, a dark background.

A 5:1 ratio (the key light is two stops greater than the fill light—4+1=5:1) and higher is considered almost a high-contrast rendition. It is ideal for creating a dramatic effect and is often used in character studies.

Shadow detail is minimal at the higher ratios and as a result, they are not recommended unless your only concern is highlight detail. This holds true for both film and digital.

○ FINDING GOOD LIGHT

Unlike the studio, where you can set the lights to obtain any effect you want, in nature you must use the light that you find. By far the best place to make outdoor family portraits is in the shade, away from direct sunlight.

Shade is nothing more than diffused sunlight. Contrary to popular belief, shade is not directionless. It has a definite direction. The best shade for groups is found in or near a clearing in the woods. Where trees provide an overhang above the subjects, the light is blocked. In a clearing, diffused light filters in from the sides, producing better modeling on the face than in open shade.

Open shade is overhead in nature and most unflattering. Like noontime sun, it leaves deep shadows in the eye sockets and under the nose and chin of the subjects. The best kind of shade comes from an angle. If forced to shoot your family group in open shade, you must fill in the daylight with a frontal flash or reflector.

Another popular misconception about shade is that it is always a soft light. Particularly on overcast days, shade can be actually be harsh, producing bright highlights and deep shadows, especially around midday. Move under an overhang, such as a tree with low-hanging branches or a covered porch, and you will immediately notice that the light is less harsh and has good direction. The quality of light will also be less overhead in nature, coming from the side, not obscured by the overhang.

○ THE BEST LIGHT

As many of the great photographs in this book illustrate, the best time of day for making great family portraits is just after the sun has set. The sky becomes a huge softbox and the effect of the lighting on your subjects is soft and even, with no harsh shadows.

There are two problems with working with this great light. One, it's dim. You will need to use medium to fast film or an equivalent digital ISO setting combined with slower shutter speeds, which can be problematic if there are children involved. Working in subdued

Deanna Urs carted this beautiful love seat out into the prairie grass for a once-in-a-lifetime shot of mother and daughter. Deanna waited until the light was skimming across the grass late in the day. The lighting is very open in the shadows due to the lateness of the day. Maybe the best prop of all here was the stepladder that got Deanna up over the set to make the shot.

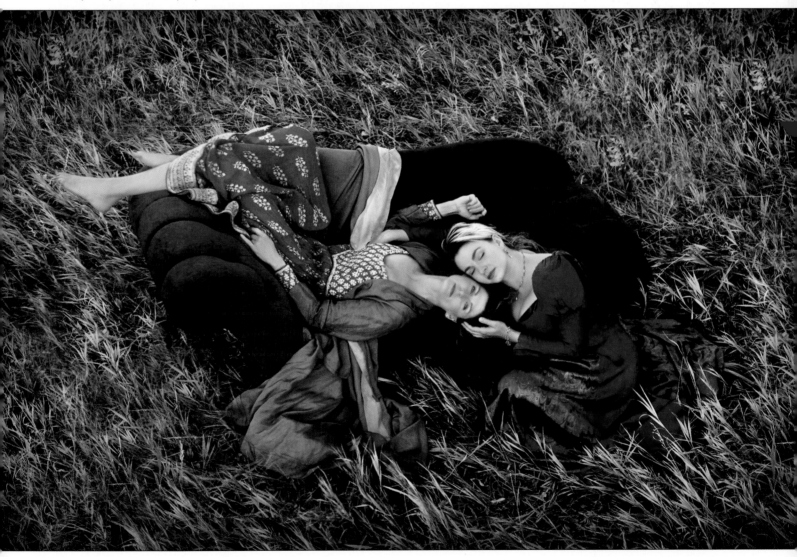

light also restricts your depth of field by virtue of having to choose wide lens apertures. The second problem in working with this light is that twilight does not produce catchlights, the white specular highlights in the eyes of the subjects. For this reason, most photographers augment the twilight with some type of flash, either barebulb flash or softbox-mounted flash that provides a twinkle in the eye.

○ ONE MAIN LIGHT

Just as in the studio, it is important to have only one key light in your family portraits. This is a fundamen-

Ordinarily, a portrait made in open shade is nothing but problems. Here, Janet Baker-Richardson observed that there was plenty of fill-in illumination from surrounding sand and stone, voiding the overhead nature of the shade. She photographed these brothers with unusual expressions on their faces—not exactly overjoyed to be having their portrait made, but charming nonetheless.

tal in all portraiture. Other lights can modify the key light, but, just as in nature, there should be a single main light source. Most photographers who shoot a lot of group portraits subscribe to the use of a single key light for groups, indoors or out, and filling the shadows of the key light with one or more flash units.

○ REFLECTORS

You are at the mercy of nature when you are looking for a lighting location. Sometimes it is difficult to find the right type of light for your needs. It is a good idea to carry along a selection of portable light reflectors. The size of the reflector should be fairly large—the larger it is, the more effective it will be. Portable light discs, which are reflectors made of fabric mounted on flexible and collapsible circular or rectangular frames, come in a variety of diameters and are a very effective means of fill-in illumination. They are available from a number of manufacturers and come in silver (for max-

imum fill output), white, gold foil (for a warming fill light), and black (for subtractive effects).

When the shadows produced by diffused light are harsh and deep, or even when you just want to add a little sparkle to the eyes of your subjects, use a large reflector or even several reflectors. It helps to have an assistant or several light stands with clamps so that you can precisely set the reflectors. Be sure to position them outside the frame. With foil-type reflectors used close to the subject, you can even sometimes overpower the ambient light, creating a pleasing and flattering lighting pattern.

Reflectors should be used close to the subjects, just out of view of the camera lens. You will have to adjust the reflector(s) several times to create the right amount of fill-in. Always observe lighting effects from the camera position. Be careful about bouncing light in from beneath your subjects. Lighting coming from under the eye/nose axis is generally unflattering. Try to "focus" your reflectors (this really requires an assistant), so that you are only filling the shadows that need filling in.

○ FILL-IN FLASH

A more predictable form of fill-in is electronic flash. As mentioned, many photographers shooting family portraits use barebulb flash, a portable flash unit with a vertical flash tube, like a beacon, that fires the flash a full 360 degrees with the reflector removed. You can use as wide a lens as you own and you won't get flash falloff with barebulb flash. Barebulb flash produces a sharp, sparkly light, which is too harsh for almost every type of photography except outdoor groups. The trick is not to overpower the daylight. This is the best source of even fill-in illumination. Look at the environmental portraits by Bill McIntosh that are sprinkled throughout this book. In each of his outdoor portraits he uses a 50 watt-second barebulb flash to either fill in backlit

Rick Ferro created this wonderful "family" portrait. The lighting is available shade coming in from either side of the group. To fill in the shadows, Rick used reflectors positioned closely to give plenty of light and also to create nice catchlights in the eyes. Rick used a Fuji Finepix S2 Pro with an 80–200mm f/2.8 lens at the 90mm setting at ISO 200. The exposure was ⅟₆₀ second at f/8.

subjects or to add a little punch to sunlit subjects when the sun is very low, as it is early in the morning or at sunset.

Some photographers like to soften their fill flash. Robert Love, for example, uses a Lumedyne strobe inside of a 24-inch softbox. He triggers the strobe cordlessly with a radio remote control. Instead of using the fill-in flash head on a slight angle, which is customary, he often uses his flash at a 45-degree angle to his subjects (for small groups) for a modeled fill-in. For larger groups, he uses the softbox next to the camera for more even coverage.

Other photographers, especially those shooting 35mm systems, prefer on-camera TTL (through-the-

When the light is good, fill flash can be used to merely put catchlights in the eyes or to open up the shadows slightly. Here, the light from the portico was excellent, but with all the dogs with dark fur, flash was needed. Tibor Imely photographed this wonderful group with a Canon EOS 1D Mark II and 150mm lens at ISO 200. The exposure was ⅟₆₀ second at f/5.6. He used a Sunpak 120 Barebulb flash to the left of camera for fill.

lens) flash. Many on-camera TTL flash systems use a mode for TTL fill-in flash that will balance the flash output to the ambient-light exposure for balanced fill flash. Many such systems are also controllable by virtue of flash-output compensation that allows you to dial in full- or fractional-stop output changes for the desired ratio of ambient-to-fill illumination. They are marvelous systems and, of more importance, they are reliable and predictable. Some of these systems also allow you to remove the flash from the camera with a TTL remote cord.

Some of the latest digital SLRs and TTL-flash systems allow you to set up remote flash units in groups, all keyed to the flash on the camera. You could, for instance, photograph a family group with four synced flashes remotely fired from the camera location, all producing the desired output for the predetermined flash-to-daylight ratio. The individual flash units used in such a setup are programmable independently so that you can vary the output of each strobe to suit your need.

○ **FLASH-FILL, METERING, AND EXPOSURE**
Here is the scenario for measuring and setting the light output for a fill-in flash situation. This will produce a true fill light with the ambient light stronger than the fill-in light.

First meter the scene. It is best to use a handheld incident flashmeter, with the hemisphere pointed at the camera from the group position. In this hypothetical example, the metered exposure is ⅟₁₅ second at f/8. Now, with a flashmeter, meter the flash only. Your goal is for the flash output to be one stop less than the ambient exposure. Adjust flash output or flash-to-subject distance until your flash reading is f/5.6. Set the camera to ⅟₁₅ second at f/8. If shooting digitally, fire

TOP—In flash-fill situations, you can overpower the daylight with the flash either to saturate the background colors, such as a sunset, or to darken the background to make it look like a different time of day. Here, the latter reason was chosen. The flash is almost two stops more intense than the daylight and off to the side to produce good modeling on the subjects. Photo by Bill McIntosh. **BOTTOM**—Bill McIntosh used late-afternoon light to rim-light his young subjects. He fired a flash at the same lens aperture as the daylight reading to provide perfect fill-in on the subjects and split-rail fence. He used a Mamiya RZ 67, 150mm f/3.5 lens, and an exposure of $\frac{1}{125}$ second at f/5.6. Notice that, in this portrait, Bill employed one of the most graceful design elements in all of art, the sweeping "S" curve of the path behind the sisters.

off a frame and check that you like the flash-to-ambient light ratio and that the exposure is good.

If the light is dropping or the sky is brilliant in the scene and you want to shoot for optimal color saturation in the background, overpower the daylight with flash. Returning to the hypothetical situation where the daylight exposure was $\frac{1}{15}$ second at f/8, now adjust your flash output so your flash reading is f/11, a stop more powerful than the daylight. Set your camera to $\frac{1}{15}$ second at f/11. The flash is now the key light and the soft twilight is the fill light. The problem with this is that you will get a separate set of shadows from the flash. This can be okay, however, since there aren't really any shadows from the twilight. Keep in mind that it is one of the side effects.

Remember that electronic flash falls off in intensity quickly, so be sure to take your meter readings from the center of your group and even from either end to be on the safe side. With a small group of three or four, you can get away with moving the strobe away from the camera to get better modeling, but not with larger groups, as the falloff is too great. You can, however, add a second flash of equal intensity and distance on the opposite side of the camera to help widen the light.

Remember that you are balancing two light sources in one scene. The ambient light exposure will dictate the exposure on the background and the subjects. The flash exposure only affects the subjects. When you hear of photographers "dragging the shutter," it refers to using a shutter speed slower than X-sync speed in order to expose the background properly. Understanding this concept is a prerequisite for effectively using flash fill.

○ DIRECT SUNLIGHT

Sometimes you are forced to photograph families in bright sunlight. While not the best scenario, a good image is still possible. Turn your group so the direct sunlight is backlighting or rim lighting the subjects. This voids the harshness of the light and prevents your subjects from squinting. Of course, you need to add fill to the front of the subjects with strobe (reflectors would cause your subjects to squint) and you must also be careful not to underexpose the image, which is a common problem in backlit scenes. Also, in backlit portraits, it is best to increase the exposure by a third to a half stop to open up the skin tones.

Don't trust your in-camera meter in backlit situations. It will read the bright background and highlights on the hair instead of the exposure on the faces. If you expose for the background light, you will silhouette the subjects. If you have no other meter than the in-camera one, move in close and take a close-up reading on your subjects. It is really best to use a hand-held incident meter in backlit situations. Be sure, however, to shield the hemisphere from direct backlight when taking a reading for the faces.

If the sun is low in the sky, you can use cross lighting (split lighting) to get good modeling on your group. Almost half of the face will be in shadow while the other half is highlighted. You must be careful to position subjects so that the sun's side lighting does not hollow out the eye sockets on the highlight side of the face. You must also position your subjects so that one person's head doesn't block the light striking the person next to him or her. There must be adequate fill-in so that the shadows don't go dead. Try to keep your fill-in flash output equal to or about a stop less than your daylight exposure.

○ PROBLEMS OUTDOORS

One thing you must watch for outdoors is subject separation from the background. A dark-haired group against a dark-green forest background will not separate tonally, creating a tonal merger. Controlling the amount of flash fill or increasing the background exposure would be logical solutions to the problem.

Natural subject positioning is sometimes a problem when you are working outdoors. If one is available, a fence makes a good subject support. If you have to

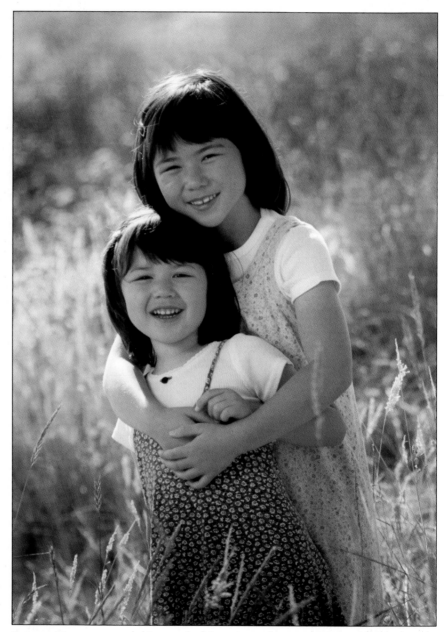

Frances Litman created this wonderful portrait of two sisters backlit by the sun. The wheat provides a natural fill-in source, so all Frances had to do to get a great exposure was bias it slightly towards the shadows. The highlights in the girls' hair are a little on the hot side, but the facial lighting is excellent.

One of the problems you will encounter with outdoor light is spotty light, which is partly direct and partly diffused. Your best bet is to find an area that is mostly in shade and use a flash to fill in any shadows. In this portrait by Phil Kramer, the lighting on the kids was made acceptable and the background and foreground remained "spotty."

pose the group on the ground, be sure it is not wet or muddy. Bring along a small blanket, which, when folded, can be hidden beneath the subjects. It will ease the discomfort of posing for a long session and also keep the subjects clean and dry.

If possible, always shoot with a tripod. Shutter speeds will generally be on the slow side, especially when shooting in shade. Also, a tripod helps you com-

pose more carefully and gives you the freedom to walk around the scene and adjust things as well as to converse freely with your subjects.

Another problem you may encounter is excess cool coloration in portraits taken in shade. If your subject is standing in a grove of trees surrounded by green foliage, there is a good chance green will be reflected into the group. If the subject is exposed to clear, blue,

Direct sunlight filtered somewhat by trees and the atmosphere was used to light this striking profile by Monte Zucker. In addition, he used a 135mm Canon Soft Focus lens wide open, which further reduced the overall contrast of the light. Notice how the young girl's gaze is not straight out on a line with the nose, but somewhere between the camera and 90 degrees. This is so you can see more of her eye.

open sky, there may be an excess of cyan in the skin tones. This won't affect your black & white shots, but when working in color, you should beware.

One way to correct this coloration (for film) is to use color-compensating (CC) filters over the lens. These are usually gelatin filters that fit in a gel filter holder. To correct for excess green coloration, use a CC 10M (magenta) or CC 15M filter. To correct for a cyan coloration, use a CC 10R (red) or CC 15R filter. This should neutralize the color shift in your scene. Alternately, you can use warming filters, of which there are quite a few. These will generally correct the coolness of shade scenes. Perhaps the easiest way to deal with off color skin tones is to use fill flash at the same aperture as the existing light. This will neutralize the color shift in the shadows.

If shooting digitally, a custom white balance reading in such conditions is recommended. Often you will still have to make subtle adjustments in Photoshop. One technique that is quite easy is to use Selective Color (Image>Adjustments>Selective Color). In the dialog box that appears, select "neutrals" from the drop-down menu and either add magenta (to minimize green skin tones) or subtract cyan (to correct cyan skin tones). Sometimes it is a combination of green and cyan that you want to correct, so both sliders will be employed. Note that if you add color you will often add overall density to the image, so you may have to reduce the "black" slider slightly to compensate.

The key to lighting family groups is to light the subjects evenly from left to right and from front to back. There cannot be any "holes" in the lighting, and this is particularly difficult with large family groups.

It is irrelevant to talk about portrait lighting patterns here (like Paramount, loop, and Rembrandt lighting). Instead, you should be concerned about getting the lights high enough to model the subjects' faces and getting the light off to the side so that it is not a flat, frontal lighting. But again, these aspects of the lighting are dictated by the size of the group and the area in which you must photograph them. What is important is that you create a one-light look, as you'd

The beauty of studio lighting is that you can sculpt the light to fit the group. Frank Frost used a large soft main light (a round softbox) to the right of the camera and soft hair lights (striplights or mini softboxes) above to create beautiful highlights on the family's hair. The main light was feathered so that it was even across the group. Reflectors out of the view of the lens helped fill in areas unaffected by the main light.

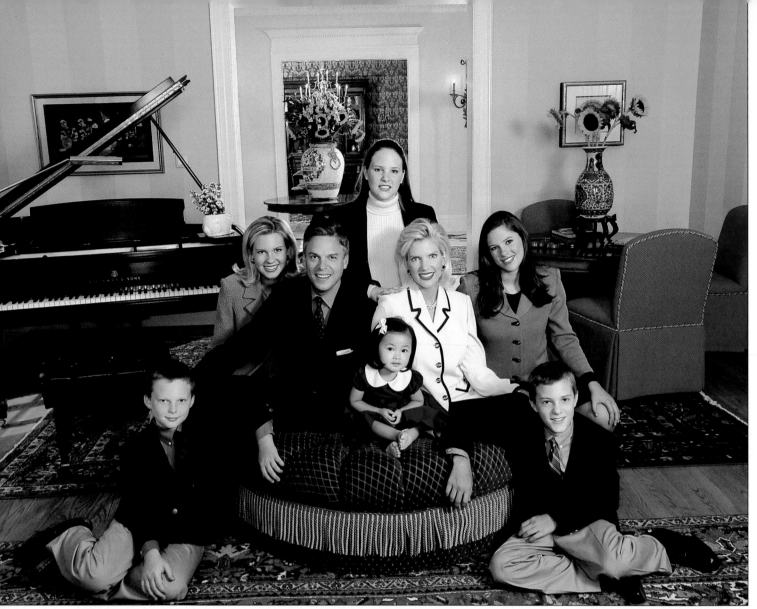

ABOVE—The Huntsman Family was photographed for *Home & Design* magazine. For this portrait, Bill McIntosh combined portrait lighting with architectural lighting. The group was lighted with a main strobe with 31-inch umbrella placed 45 degrees to the right of the group. A similar strobe was behind the camera as fill light. A strobe with barn doors was placed in the foyer, backlighting the group. Two strobes with barn doors lighted the right and left walls of the foyer and the vase with sunflowers. The room in the back with the red wallpaper was lighted with one strobe bounced off the ceiling. Fuji NPH 400 film allowed the exposure to be between f/16 and f/22 to get the layers of space in the three rooms in focus. The exposure was ¼ second at between f/16 and f/22 to capture the candles in the foyer and the back room. Bill used a Mamiya RZ67 with 65mm lens. **FACING PAGE**—Stacy Bratton learned to light her subjects in a small studio that could not accommodate two umbrellas to cross-light a seamless background. She resorted to using a drop ceiling made of Fome-Cor and bounce flash for a fill light. Now that she has an 11,000 square-foot studio, she prefers to light the way she learned. She uses a 72-inch Chimera Soft Pro softbox for a key, and her drop-ceiling fill light.

find in nature. Various sources of fill light will be discussed throughout, but in every instance, one should strive for a single main-light look in indoor lighting.

○ FEATHERING

Feathering means using the edge rather than the hot core of the light source. If you aim a light source directly at your subjects, you will find that while the strobe's modeling light might trick you into thinking the lighting is even, it is really falling off at the ends of the group. Feathering will help to light your group more evenly because you are aiming the light source past the subjects, using the edge of the light.

Feathering might call for aiming the light up and over the group, using just the edge of the light to illuminate each of the subjects. However, since you are

RIGHT—Deanna Urs created this striking portrait of a young girl in her home using a single softbox to light the set. No fill light was used and the highlight side of the face was lightened so that Deanna could add handcoloring to the cheeks and lips. The effect of a single light and a single catchlight in the eyes produces a dramatic effect. **FACING PAGE**—Judy Host made this gorgeous window-light portrait. Notice the subtle gradation in the highlights, particularly along the bridge of her nose. This is a function of good lighting and accurate exposure. Judy used no fill light except the ambient fill in the room. It is an elegant child portrait that any parent would love.

using the edge of the light, you will sometimes cause the level of light to drop off. Always check the results in the viewfinder and with a meter.

Another trick is to move the light source back so that it is less intense overall but covers a wider area. The light will be harsher and less diffused the farther you move it back.

○ LIGHTING A LARGE GROUP
Umbrella Lighting. Umbrella lights are best used for large groups. Usually the umbrellas are positioned on either side of the camera, equidistant to the group and the camera so the light is even. The lights are feathered so there is no hot center to the lighting and they are slaved (with either radio or optical slaves) so that when the photographer triggers the main flash (either on-camera or off-camera flash), all of the umbrellas will fire in sync.

Focusing Umbrellas. Umbrellas fit inside a tubular housing in most studio electronic flash units. The umbrella slides toward and away from the flash head and is anchored with a set-screw or similar device. The reason the umbrella-to-light-source distance is adjust-

able is that there is a set distance at which the full amount of strobe light hits the complete surface of the umbrella. This is optimal. If the umbrella is too close to the strobe, much of the beam of light is focused past the umbrella surface and goes to waste. When setting up, use the modeling light of the strobe to focus the distance correctly, so the outer edges of the light core strike the outer edges of the umbrella for maximum light efficiency.

Bounce Lighting. Another means of lighting large family groups is to bounce undiffused strobes off the ceiling to produce an overhead type of soft light. This light will produce an even overall lighting but not necessarily the most flattering portrait light. You can then use a more powerful (by about one stop) umbrella flash at the camera (slightly higher than the group and slightly to one side) to produce a pleasant modeling effect. The bounce light acts as fill, while the umbrella flash acts as a main light. Be sure to meter the fill lights and the main light separately and expose for the main light.

Quartz-Halogen Lighting. Quartz-halogen lights can be used similarly. Since these lights are tungsten-

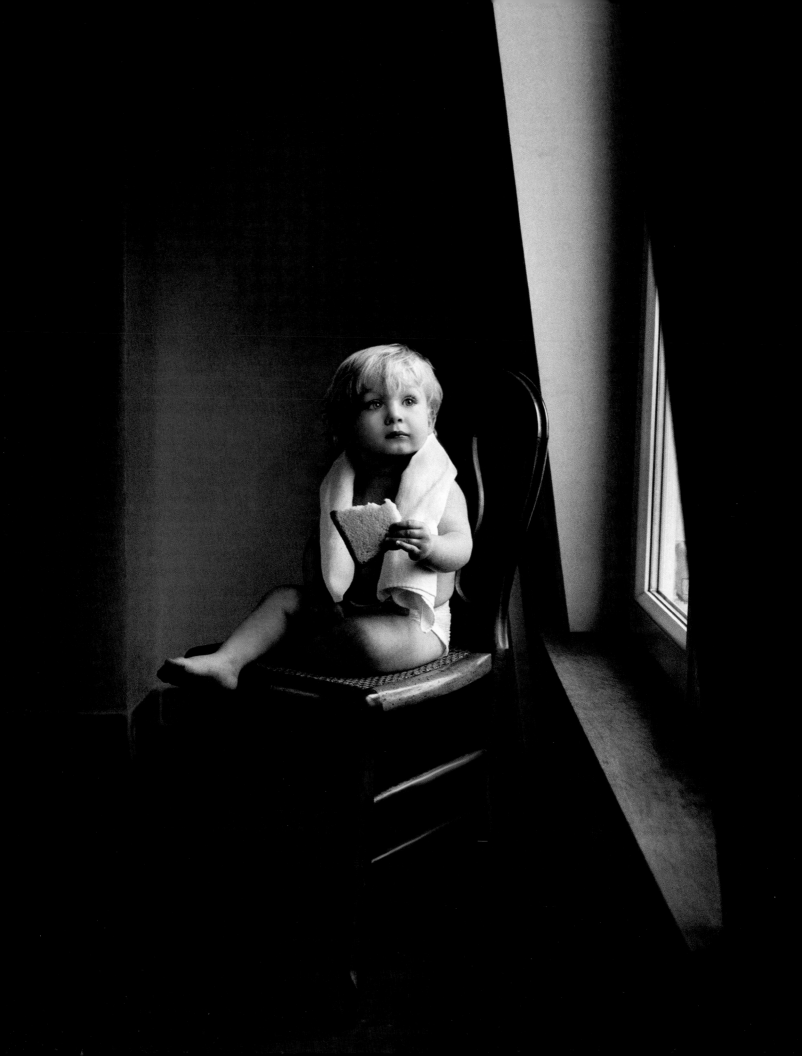

balanced, you must use tungsten-balanced film or the tungsten white-balance setting on your digital camera. These lights provide the same flexibility as strobes—and perhaps even more, because you can see the light falloff and use your in-camera meter for reliable results.

Whether you're using quartz lights or strobes in umbrellas, it is imperative to locate and secure the lights safely. Because family portraits involve lots of people, and usually a number of children, your subjects could easily trip over the stands or any wires that are not completely taped down with duct tape. The last thing you want is for someone to be injured due to your carelessness.

○ WINDOW LIGHT

One of the most flattering types of lighting you can use in family portraiture is window lighting. It is a soft light that minimizes facial imperfections and is also a highly directional light, yielding good roundness and modeling qualities in portraits. Window light is usually a fairly bright light, and it is infinitely variable, changing almost by the minute, allowing a great variety of moods in a single shooting session.

Window lighting has several drawbacks, as well. Since daylight falls off rapidly once it enters a window and is much weaker several feet from the window than it is close to the window, great care must be taken in deter-

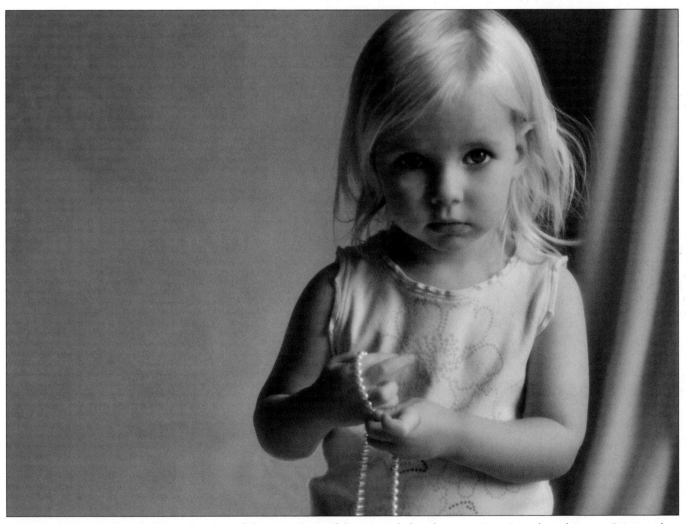

FACING PAGE—Window light can be one of the most beautiful portrait lights there is. Here, Joseph and Louise Simone photographed this youngster with a wide-angle lens to take in much of the room and its unusual angles. The boy was positioned close to the window for maximum soft light. A reflector fill was used from the left side of the set to fill in just enough of the shadow areas to give them detail but not enough to lessen the lighting ratio, which is a healthy 4:1 ratio. The use of a wide-angle lens for portraiture requires that the subject be close to the center of the frame to avoid distortion. **ABOVE**—Judy Host uses primarily window light with all her subjects. Here, the very soft window light and pleasing line of the drape behind the young girl creates a memorable portrait. The closer you place your subject to the light source, the softer and larger the light source will be.

Marcus Bell used a single self-contained umbrella for a very soft and controlled lighting effect. No fill was necessary, even though the light was off camera axis. It's the perfect lighting for a relaxed portrait of a boy and his sisters.

Subject Positioning. One of the most difficult aspects of shooting window-light portraits is positioning your subjects so that there is good facial modeling. If the subjects are placed parallel to the window, you will get a form of split lighting that can be harsh. It is best to position your subjects away from the window slightly so that they can look back toward the window. Thus, the lighting will highlight more area on the faces.

The closer to the window your subjects are, the harsher the lighting will be. The light becomes more diffused the farther you move from the window. Usually, it is best to position the subjects 3–5 feet from the window. This not only gives better lighting but gives you a little room to produce a flattering pose and pleasing composition.

Exposure. The best way to meter for exposure is with a handheld incident meter. Hold it in front of each of the subjects' faces in the same light and take a reading, pointing the light-sensitive hemisphere directly at the lens. With more than one subject, you'll get multiple readings. Choose an exposure midway between the two or three readings. Whatever direction the faces are turned (i.e., toward the window or toward the camera), place the meter's hemisphere at the same angle for a more accurate reading.

If using a reflected meter, like the in-camera meter, move in close and take readings off the faces. If the subjects are particularly fair-skinned, remember to open up at least one f-stop from the indicated reading. Most camera light meters take an average reading, so if

mining exposure, particularly with groups of three or four people. Another problem arises from shooting in buildings not designed for photography. You will sometimes have to work with distracting backgrounds and uncomfortably close shooting distances.

The best quality of window light is the soft, indirect light of mid-morning or mid-afternoon. Direct sunlight is difficult to work with because of its intensity and because it will often create shadows of the individual windowpanes on the subject. It is often said that north light is the best for window-lit portraits. This is not necessarily true. Good-quality light can be had from a window facing any direction, provided the light is soft.

you move in close on a person with an average skin tone, the meter will read the face, hair, and what little clothing and background it can see and give you a fairly good exposure reading. Average these readings and choose an intermediate exposure setting.

Since you will be using the lens at or near its widest aperture, it is important to focus carefully. Focus on the eyes and, if necessary, adjust members of the group forward or backward so they fall within the same focus plane. Depth of field is minimal at these apertures, so control the pose and focus as carefully as possible and be sure light falls evenly on all the faces.

Fill-In Illumination. One of the problems with window light is that there is not adequate fill light to illuminate the shadow side of the faces. The easiest way to fill the shadows is with a large white or silver fill reflector placed next to the subject on the side opposite the window. The reflector has to be angled properly to direct the light back into the faces.

If you are shooting a ³/₄- or full-length portrait, a fill card may not be sufficient, and it may be necessary to provide another source of illumination to achieve a good fill-in balance. Sometimes, if you flick on a few room lights, you will get good overall fill-in. Other times, you may have to use bounce flash.

If using the room lights for fill, be sure they do not overpower the window light, creating multiple lighting patterns. If the light is direct (casts its own set of

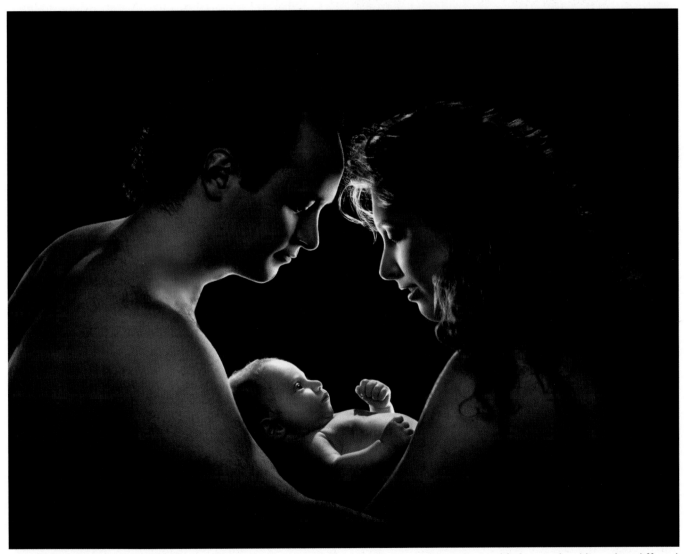

Incredible lighting is the hallmark of Joseph and Louise Simone's portraits. Here, the mother and father are backlit with undiffused lights and barn doors. The spill light from the backlights produces an elegant lighting pattern on the shadow sides of the faces. The baby is also lit using the same light. On the camera side, great care is taken to produce an overall fill level that makes the skin glow. This is a marvelous portrait.

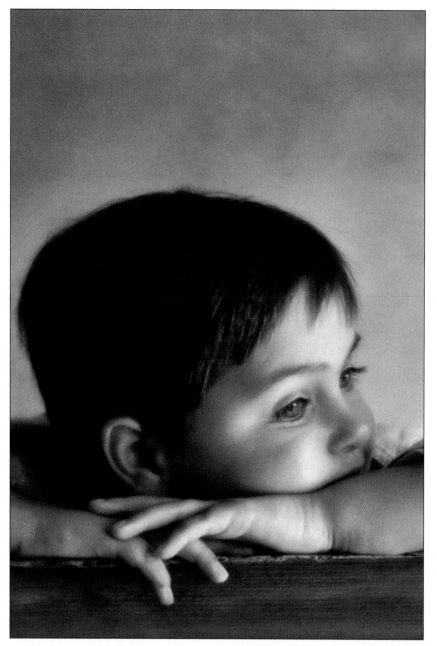

Judy Host had her young subject turn toward the window light and waited until he started to daydream. Notice how the light colors his eyes, giving them an unusual blue/violet aura.

view so it lights just the wall behind the subject.

If none of the above methods of fill-in is available to you, use bounce flash. You can bounce the light from a portable electronic flash off a white card or the ceiling, or into an umbrella or a far wall, but be sure that it is ½ to one full f-stop less intense than the daylight. It is important when using flash for fill-in to carry a flashmeter for determining the intensity of the flash.

Diffusing Window Light. If you find a nice location for a portrait but the light coming through the windows is direct sunlight, you can diffuse the window light with some acetate diffusing material taped to the window frame. It produces a warm golden window light. Light diffused in this manner has the feeling of warm sunlight but without the harsh shadows. If still too harsh, try doubling the thickness of the acetate for more diffusion. When used on a movie set, these diffusers are called scrims. Since the light is so scattered by the scrim, you will probably not need a fill source unless you are working with a

noticeable shadows), then you are better off using another type of fill-in.

When using daylight-balanced color film or a daylight white-balance setting on your digital camera, you will get a warm glow from the tungsten room lights. This is not necessarily objectionable as long as the light is diffused and not too intense.

It is a good idea to have a room light in the background behind the subject. This opens up an otherwise dark background and provides better depth in the portrait. If possible, you should position the background room light behind the subject, out of view of the camera, or off to the side and out of the camera's field of

larger group. In that case, you can use reflectors to bounce light back into the faces of those farthest from the window.

○ BOUNCE FLASH

Portable electronic flash is the most difficult of one-light applications. Portable flash units do not have modeling lights, so it is impossible to see the lighting effect. However, there are certain ways to use a portable flash in a predictable way to get excellent portrait lighting for family groups.

Bounce flash is an ideal type of portrait light. It is soft and directional. By bouncing the flash off the ceil-

ing or a side wall, you can achieve an elegant wrap-around-style lighting that illuminates the subjects beautifully.

If you are using side-wall bounce flash, you will probably need to position a reflector at an angle to the group to kick in some much-needed fill light.

You must learn to mentally gauge angles when using bounce flash. Aim the flash unit at a point on the wall or ceiling that will produce the widest beam of light reflecting back onto your subjects.

You should never make color exposures when bouncing flash off colored walls. The light reflected back onto your subjects will be the same color as the walls or ceiling.

Lighting Large Groups with Bounce Flash. One way to light large family groups is to bounce multiple flashes off a white ceiling. The studio strobes, used in short parabolic reflectors, should be positioned to either side of the camera but not in the lens's field of view. This gives an overall even lighting pattern. It is also a good idea to create a low lighting ratio such as 1:2 or 1:2.5, but never 1:4 or higher—the light is too hard to control.

The best means of determining exposure is with a flashmeter. Use it at the group position to take read-ings at either end of the group and in the middle. You should not have more than one- or two-tenths of a stop difference between any of the readings.

You must determine the angle of incidence (what goes up) and the angle of reflection (what comes down) in order to properly set up bounce lights, par-ticularly with studio-type strobes with minimal model-ing lights. Choose the angle from the flash to the ceil-ing carefully, because the angle from the ceiling to the subject will be the same angle. Do not to get the strobes too close to the group; otherwise, you will pro-duce an overhead type of lighting. With the right angle, bounce flash will eliminate the need for retouch-ing. Its soft, wraparound effect is ideal for medium- to large-size groups.

With quartz lights, which are extremely bright, you will be able to see the exact effect you will get and meter it to make sure the lighting is even. With strobes, on the other hand, you must set the lights carefully. Flash is unpredictable at best. Previewing a test exposure on the camera's LCD will reveal much-needed information about exposure, light quality, and the evenness of the lighting. A digital camera will allow you to preview the effectiveness of your lighting instantly.

A man and his cats qualifies as a modern-day family portrait. David Bentley, who is gifted at photographing animals in a portrait envi-ronment, created two strong diagonals—one with the man's legs, by virtue of his reclining pose, and the other from the meandering line of the four cats. The two lines intersect at the man's face, the central area of impor-tance. Notice how each cat photographs uniquely.

The Photographers

Janet Baker Richardson. From a successful career as a producer of television commercials, Janet was drawn towards photographing children by the simplicity and honesty of the profession. Not having the funds, at the time, for studio lights, she mastered the use of outdoor and window light and has subsequently created a meaningful niche in the world of children's portraiture. Janet lives with her family in Los Angeles, where she runs a home-based business.

Marcus Bell. Marcus Bell's creative vision, fluid natural style, and sensitivity have made him one of Australia's most revered photographers. It's this talent, combined with his natural ability to make people feel at ease, that attracts his clients. His work has been published in numerous magazines in Australia and overseas including *Black White, Capture, Portfolio, Bride,* and countless other bridal magazines.

David and Susan Bentley. David and Susan Bentley own and operate Bentley Studio, Ltd. in Frontenac, Missouri. Both David and Susan are Master Photographers. With a background in engineering, David calls upon a systematic as well as a creative approach to assignments. Thirty years of experience and numerous awards speak to the success of this system.

Stacy Dail Bratton. Stacy Bratton is a commercial and portrait photographer, author, and owner of SD/SK Studio in downtown Dallas, TX. She is an accomplished children's and family photographer, having shot more than 2500 baby portraits over the years. She is a graduate of Art Center College of Design in Pasadena, California, and the author of *Baby Life* (Taylor Trade Publishing, 2004), a book featuring 75 of her black & white children's photographs.

Anthony Cava, BA, MPA, APPO. Born and raised in Ottawa, Ontario, Anthony Cava owns and operates Photolux Studio with his brother, Frank. Frank and Anthony's parents originally founded Photolux as a wedding/portrait studio, thirty years ago. Anthony joined WPPI and the Professional Photographers of Canada ten years ago. At one time, he was the youngest Master of Photographic Arts (MPA) in Canada. Cava won WPPI's Grand Award for the year with the first print that he ever entered in competition.

Frank Cava. The co-owner of Photolux Studio in Ottawa, Frank is a successful and award-winning wedding and portrait photographer. He is a member of the Professional Photographers of Canada and WPPI. With his brother Anthony, he also speaks to professional organizations in the U.S. and Canada.

Deborah Lynn Ferro. A professional photographer since 1996, Deborah calls upon her background as a watercolor artist. In addition to being a fine photographer, she is also an accomplished digital artist. She is the author of *Artistic Techniques with Adobe® Photoshop® and Corel® Painter®,* and (with her husband, Rick Ferro) the coauthor of *Wedding Photography with Adobe® Photoshop®,* both from Amherst Media.

Rick Ferro, PPA Cert., M.Photog. Rick Ferro has served as senior wedding photographer at Walt Disney World. In his twenty years of photography experience, he has photographed over 10,000 weddings. He has received numerous awards, including having prints accepted into PPA's Permanent Loan Collection. He is the author of *Wedding Photography: Creative Techniques for Lighting and Posing* and coauthor of *Wedding Photography with Adobe® Photoshop®,* both published by Amherst Media.

Frank A. Frost, Jr., PPA-Certified, M.Photog., Cr., APM, AOPA, AEPA, AHPA. Frank Frost has been creating his classic portraiture in Albuquerque, NM, for over eighteen years. Believing that "success is in the details," Frank pursues both the artistry and business of photography with remarkable results, earning him numerous awards from WPPI and PPA along the way. His photographic ability stems from an instinctive flair for posing, composition, and lighting.

Jennifer George Walker. Jennifer George Walker runs her studio out of her home in the San Diego, CA, community of Del Mar. The affluent neighborhood is close to the beach and a variety of beautiful shooting locations, and is lush with prospective clients. She has won the California Photographer of the Year, and been the winner of the People's Choice Award 2001 at the Professional Photographers of California

Convention. In 2003, Jennifer was the Premiere category Grand Award winner. You can view more of Walker's images at www.jwalkerphotography.com.

Judy Host. Judy Host has won numerous awards for her photography and has been featured in a number of publications for her outstanding environmental portraiture. The PPA, from whom she has received Masters and Craftsman degrees, has selected her work for National Exhibition. In 1999, Judy received her first of three Kodak Gallery Awards. Many of her images have been exhibited at Epcot Center and are part of a traveling loan collection.

Tibor Imely. Imely Photography is one of the most prestigious studios in the Tampa Bay area. Tibor has won numerous awards, including his most recent: the Accolade of Photographic Mastery and Accolade of Outstanding Achievement from WPPI. Tibor was also recently presented with a Fujifilm New Approach Award for new and innovative solutions to tried-and-true photographic methods.

Kevin Jairaj. Kevin Jairaj is an award-winning wedding and portrait photographer whose creative eye has earned him a stellar reputation in the Dallas/Fort Worth, TX, area. He is formerly a fashion photographer who uses skills learned in that discipline when shooting his weddings and portraits. His web site is www.kjimages.com/.

Tim Kelly. Tim Kelly has won almost every available photography award (including PPA Loan Collection, Kodak Gallery, Gallery Elite, and Epcot Awards) and holds both the Master of Photography and Photographic Craftsman degrees. Kelly, a long time member of Kodak's Pro Team, has been under the wing of their sponsorship since 1988. In 2001, Kelly was awarded a fellowship in the American Society of Photographers and named to the prestigious Cameracraftsmen of America. Kelly Studio and Gallery in the North Orlando suburb of Lake Mary, FL, is the epitome of a high-end creative environment.

Phil Kramer. In 1989, after graduating from the Antonelli Institute of Art and Photography, Phil Kramer opened his own studio, Phil Kramer Photographers, specializing in fashion, commercial, and wedding photography. Today, Phil's studio is one of the most successful in the Philadelphia area and has been recognized by editors as one of the top wedding studios in the country. Recently, he opened offices in Princeton, NJ, New York City, Washington, DC, and West Palm Beach, FL. An award-winning photographer, Phil's images have appeared in numerous magazines and books both here and abroad. He is also a regularly featured speaker on the professional photographers' lecture circuit.

Cal Landau. Cal Landau was an art major in college in the late 1960s. Although his mother had been a talented painter her whole life, however, he did not inherit those skills—so he spent the next 30 years trying to become a professional racing driver. His father was always a photographer hobbyist and gave him a Nikkormat, with which he took pictures of auto racing and bicycle racing for small magazines for fun. One day, someone who crewed for his racecar asked him to shoot his wedding. Cal turned him down a few times and finally gave in. "Of course everyone knows the rest of the story," he says. "I fell in love with this job. So, I am a very late bloomer and I pinch myself every day for how good I have it."

Frances Litman. Frances Litman is an internationally known, award-winning photographer from Victoria, British Columbia. She has been featured by Kodak Canada in national publications, and has had her images published in numerous books, on magazine covers, and in FujiFilm advertising campaigns. She was awarded Craftsman and Masters degrees from the Professional Photographers Association of Canada. She has also been awarded the prestigious Kodak Gallery Award and was named the Photographer of the Year by the Professional Photographers Association of British Columbia.

Robert Love, APM, AOPA, AEPA, M.Photog., Cr., CPP and **Suzanne Love, Cr. Photog.** Robert Love is a member of Camera-craftsmen of America, one of forty active members in the world. He and his wife, Suzanne, create all of their images on location. Preferring the early evening "love light," they have claimed the outdoors as their "studio." This gives their images a feeling of romance and tranquillity.

Charles and Jennifer Maring. Charles and Jennifer Maring own and operate Maring Photography Inc. in Wallingford, CT. Charles is a second-generation photographer, his parents having operated a successful studio in New England for many years. His parents now operate Rlab (www. resolutionlab.com), a digital lab which does all of the work for Maring Photography, as well as for other discriminating photographers needing high-end digital work. Charles Maring is the winner of the WPPI 2001 Album of the Year Award.

Leslie McIntosh. Recently returning to Virginia Beach to join the McIntosh family photography business, Leslie completed her Bachelor of Fine Arts degree from the Art Institute of Chicago, moving on to London and then Hamburg to build a successful career in the advertising and fashion photography business. She sensitively captures the mood of a subject's character, personality, and stage of life. Leslie has specialized in families, mothers and children, along with high school seniors, but is open to all markets.

William S. McIntosh, M.Photog., Cr. , F-ASP. Bill McIntosh photographs executives and their families all over the U.S. and travels to England frequently on special assignments. He has lectured all over the world. His popular book, *Location Portraiture: The Story Behind the Art* (Tiffen Company LLC, 1996) is sold in bookstores and other outlets

around the country. His latest book, *Classic Portrait Photography: Techniques and Images from a Master Photographer,* was published in 2004 by Amherst Media.

Melanie Nashan. Melanie Maganias Nashan, founder of Nashan Photographers, Inc. in Livingston, MT, specializes in weddings but also photographs portraits, commercial work, and architecture. Her striking images have been published in *Martha Stewart Weddings, The Knot, Bride's, Modern Bride,* and *Sunset Magazine.* In 2003, she was chosen as one of America's top fifteen wedding photographers by *PDN (Photo District News),* a trade magazine.

Larry Peters. Larry Peters is one of the most successful and award-winning teen-and-senior photographers in the nation. He operates three highly successful studios in Ohio and is the author of two books, *Senior Portraits* (self published, 1987) and *Contemporary Photography* (self published, 1995). His award-winning web site is loaded with good information about photographing seniors: www.petersphotography.com

Parker Pfister. Parker Pfister, who shoots weddings locally in Hillsboro, OH, as well as in neighboring states, is quickly developing a national celebrity. He is passionate about what he does and can't imagine doing anything else (although he also has a beautiful portfolio of fine-art nature images). Visit him at www.pfisterphoto-art.com/.

Norman Phillips, AOPA. Norman Phillips has been awarded the WPPI Accolade of Outstanding Photographic Achievement (AOPA). He is a registered Master Photographer with Britain's Master Photographers Association, a Fellow of the Society of Wedding & Portrait Photographers, and a Technical Fellow of Chicagoland Professional Photographers Association. He is a frequent contributor to photographic publications and coauthor of *Wedding and Portrait Photographers' Legal Handbook* (Amherst Media, 2005).

Fran Reisner. Fran Reisner is an award-winning photographer from Frisco, TX. She is a Brooks Institute graduate and has twice been named Dallas Photographer of the Year. She is a past president of the Dallas Professional Photographers Association. She runs a highly successful portrait and wedding business from the studio she designed and built on her residential property. She has won numerous state, regional, and national awards for her photography.

Martin Schembri, M.Photog., AIPP. Martin Schembri has been winning national awards in Australia for twenty years. He has achieved a Double Master of Photography degree from the Australian Institute of Professional Photography. He is an internationally recognized portrait, wedding, and commercial photographer and has conducted worldwide seminars on his unique style of creative photography.

Brian and Judith Shindle. Brian and Judith Shindle own and operate Creative Moments in Westerville, OH. This studio is home to three enterprises under one umbrella: a working photography studio, an art gallery, and a full-blown event-planning business. Brian's work has received numerous awards from WPPI in international competition.

Joseph and Louise Simone. Joseph and Louise Simone of Montreal, Quebec, are marvelous photographers and teachers. They have been a team since 1975, the year they established their Montreal studio. The Simones constantly strive to give their clients a true work of art, a portrait that will pull at their heartstrings and command a very special position within the home or office—much like painted portraits have throughout history. When such a portrait is created, pricing is not an issue. The Simones have lectured in France, Italy, Spain, Belgium, Germany, Austria, Martinique, Guadeloupe, and the United States.

Deanna Urs. Deanna Urs lives in Parker, CO, with her husband and children. She has turned her love and passion for the camera into a portrait business that has created a following of clientele nationally as well as internationally. Deanna uses "natural light" and chooses to have subtle expressions from her clients as she feels these are more soulful portraits that will be viewed as art and as an heirloom. She works in her client's environment to add a personal touch her portraits. Visit Deanna's website at www.deannaursphotography.com.

David Worthington. David Worthington is a professional photographer who specializes in classical wedding photography. David is one of only two photographers in the Northwest of the UK to have one of his wedding photographs published in a book celebrating the best work over the last 50 years produced by professional photographers. This is indeed a fine achievement, as only 50 images were selected from entries sent from around the world. Two of David's most recent awards include the 2003 Classical Wedding Photographer of the Year (UK, Northwest Region) and the 2003 Licentiate Wedding Photographer of the Year (UK, Northwest Region).

Monte Zucker. When it comes to perfection in posing and lighting, timeless imagery and contemporary, yet classical photographs, Monte Zucker is world famous. He has been bestowed every major honor the photographic profession can offer, including WPPI's Lifetime Achievement Award. In 2002, Monte received the International Portrait Photographer of the Year Award from the International Photography Council, a non-profit organization of the United Nations. In his endeavor to educate photographers at the highest level, Monte, along with partner Gary Bernstein, has created an information-based web site for photographers, www.Zuga.net.

Aperture, optimum. The aperture on a lens that produces the sharpest image. It is usually two stops down from the widest aperture. If the lens is an f/2.8 lens, for example, the optimum aperture would be f/5.6.

Balance. A state of visual symmetry among elements in a photograph. *See also* Tension.

Barn doors. Black, metal folding doors that attach to a light's reflector. These are used to control the width of the beam of light.

Bounce flash. Bouncing the light of a studio or portable flash off a surface such as a ceiling or wall to produce indirect, shadowless lighting.

Box light. A diffused light source housed in a box-shaped reflector. The front is translucent material; the side pieces of the box are opaque but are coated with a reflective material such as foil on the inside to optimize light output.

Burning-in. (1) A darkroom printing technique in which specific areas of the print surface are given additional exposure in order to darken them. (2) In Photoshop, the same effect can be achieved using the Burn tool.

Burst rate. The number of frames per second (fps) a digital camera can record and the number of frames per exposure sequence a camera can record. Typical burst rates range from 2.5fps up to six shots up to 8fps up to forty shots.

Catchlight. Specular highlights that appear in the iris or pupil of the subject's eyes, reflected from the portrait lights.

CCD. Charge-coupled device. A type of image sensor that separates the spectrum of color into red, green, and blue for digital processing by the camera. A CCD captures only black & white images. The image is passed through red, green, and blue filters in order to produce color.

CC filters. Color compensating filters come in gel or glass form. Used to correct the color balance of a scene.

CMOS. Complementary Metal Oxide Semiconductor. A type of semiconductor that has been, until the Canon EOS D30, widely unavailable for digital cameras. CMOS chips consume less energy than chips that utilize simply one type of transistor.

Color management. A system of software-based checks and balances that ensures consistent color through a variety of capture, display, editing, and output device profiles.

Color space. An environment referring to the range of colors that a particular device is able to produce.

Color space, working. Predefined color management settings specifying the color profiles to be associated with the RGB, CMYK, and Grayscale color modes. The settings also specify the color profile for spot colors in a document. Central to the color management workflow, these profiles are known as working spaces. The working spaces specified by predefined settings represent the color profiles that will produce the best color fidelity for several common output conditions.

Color temperature. The degrees Kelvin of a light source. Also refers to a film's sensitivity. Color films are balanced for 5500°K (daylight), 3200°K (tungsten), or 3400°K (photoflood). Digital cameras feature white-balance controls, which attenuate the exposure for the color temperature of the light source.

Crosslighting. Lighting that comes from the side of the subject, skimming facial surfaces to reveal the maximum texture in the skin. Also called split lighting.

Cross shadows. Shadows created by lighting a group with two light sources from either side of the camera. These should be eliminated to restore the "one-light" look.

Depth of field. The distance that is sharp beyond and in front of the focus point at a given f-stop.

Depth of focus. The amount of sharpness that extends in front of and behind the focus point. The depth of focus of some lenses extends 50 percent in front of and 50 percent behind the focus point. Other lenses may vary.

Diffusion flat. Portable, translucent diffuser that can be positioned in a window frame or near the subject to diffuse the light striking the subject.

Dodging. (1) Darkroom printing technique in which specific areas of the print are given less print exposure by blocking the light to those areas of the print, making those

areas lighter. (2) In Photoshop, the same effect can be achieved using the Dodge tool.

Dragging the shutter. Using a shutter speed slower than the X-sync speed to capture the ambient light in a scene.

Feathering. Misdirecting the light deliberately so that the edge of the beam of light illuminates the subject.

Fill card. A white or silver-foil-covered card used to reflect light back into the shadow areas of the subject.

Fill light. Secondary light source used to fill in the shadows created by the key light.

Flash fill. Flash technique that uses electronic flash to fill in the shadows created by the key light.

Flash key. Flash technique in which the flash becomes the key light and the ambient light in the scene fills the shadows created by the flash.

Foreshortening. A distortion of normal perspective caused by close proximity of the camera/lens to the subject. Foreshortening exaggerates subject features—noses appear elongated, chins jut out, and the backs of heads may appear smaller than normal.

45-degree lighting. Portrait lighting pattern characterized by a triangular highlight on the shadow side of the face. Also known as Rembrandt lighting.

Full-length portrait. A pose that includes the full figure of the model. Full-length portraits can show the subject standing, seated, or reclining.

Gaussian blur. Photoshop filter that diffuses images.

Gobo. Light-blocking card that is supported on a stand or boom and positioned between the light source and subject to selectively block light from portions of the scene.

Golden mean. A rule of composition that gives a guideline for the most dynamic area in which to place the subject. Determined by drawing a diagonal line from one corner of the frame to the other, then drawing a line from either remaining corner of the frame so that the diagonal is intersected perpendicularly.

Head-and-shoulder axis. Imaginary lines running through shoulders (shoulder axis) and down the ridge of the nose (head axis). Head-and-shoulder axes should never be perpendicular to the line of the lens axis.

High-key lighting. Type of lighting characterized by a low lighting ratio and a predominance of light tones.

Histogram. A graph associated with a single image file that indicates the number of pixels that exist for each brightness level. The range of the histogram represents 0 to 255 from left to right, with 0 indicating absolute black and 255 indicating absolute white.

ICC Profile. File that contains device-specific information that describes how the device behaves toward color density and color gamut. Since all devices communicate differently, as far as color is concerned, profiles enable the color management system to convert device-dependent colors into or out of each specific color space based on the profile for each component in the workflow. ICC profiles can utilize a device-independent color space to act as a translator between two or more different devices.

Incident light meter. A handheld light meter that measures the amount of light falling on its light-sensitive dome.

JPEG. Joint Photographic Experts Group. JPEG is an image file format with various compression levels. The higher the compression rate, the lower the image quality when the file is expanded (restored). Although there is a form of JPEG that employs lossless compression, the most commonly used forms of JPEG employ lossy compression algorithms, which discard varying amounts of the original image data in order to reduce file size for storage.

Key light. The main light in portraiture used to establish the lighting pattern and define the facial features of the subject.

Kicker. A backlight (a light coming from behind the subject) that highlights the hair or contour of the body.

Lens circle. The circle of coverage; the area of focused light rays falling on the film plane or digital imaging chip.

Levels. In Photoshop, Levels allows you to correct the tonal range and color balance of an image. In the Levels window, Input refers to the original intensity values of the pixels in an image and Output refers to the revised color values based on your adjustments.

Lighting ratio. The difference in intensity between the highlight side of the face and the shadow side of the face. A 3:1 ratio implies that the highlight side is three times brighter than the shadow side of the face.

Loop lighting. A portrait lighting pattern characterized by a loop-like shadow on the shadow side of the subject's face. Differs from paramount or butterfly lighting because the key light is placed slightly lower and farther to the side of the subject.

Lossless format. Describes the compression strategy of various file formats. A lossless format does not lose any data, meaning that the file can be saved again and again without degradation.

Lossy format. Describes the compression strategy of various file formats. Lossy compression results in the loss of image data every time the image is saved.

Low-key lighting. Type of lighting characterized by a high lighting ratio and strong scene contrast as well as a predominance of dark tones.

Main light. Synonymous with key light.

Metadata. Text "tags" that accompany the digital files. Data often includes date, time, camera settings, caption info,

copyright symbol (©), and even GPS information. Metadata is accessible in Photoshop; just go to File>File Info, and from the Section pull-down menu, select EXIF.

Microdrive. Storage medium for portable electronic devices using the CF Type II industry standard. Current microdrive capacities range from 340MB to 1GB of storage. The benefit of a microdrive is high storage capacity at low cost. The downside is the susceptibility to shock—bumping or dropping a microdrive can lead to data loss.

Modeling light. A secondary light mounted in the center of a studio flash head that gives a close approximation of the lighting that the flash tube will produce. Usually high intensity, low-heat output quartz bulbs.

Noise. (1) Noise is a condition, not unlike excessive grain, that happens when stray electronic information affects the image sensor sites. It is made worse by heat and long exposures. Noise shows up more in dark areas, making evening and night photography problematic with digital capture. (2) In order to produce a grainy appearance in digital images, the Noise filter in Photoshop is sometimes used for creative effect.

Parabolic reflector. Oval dish that houses a light and directs its beam outward in an even, controlled manner.

Paramount lighting. One of the basic portrait lighting patterns, characterized by a high-key light placed directly in line with the line of the subject's nose. This lighting produces a butterfly-like shadow under the nose. Also called butterfly lighting.

Perspective. The appearance of objects in a scene as determined by their relative distance and position.

Pixel. Picture element. Smallest element used to form an image on a screen or paper. Thousands of pixels are used to display an image on a computer screen or print an image from a printer.

Point light source. A light source, like the sun, which produces sharp-edged shadows without diffusion.

RAW file. A file format that uses lossless compression algorithms to record picture data as is from the sensor, without applying any in-camera corrections. In order to use images recorded in the RAW format, files must first be processed by compatible software. RAW processing includes the option to adjust exposure, white balance, and the color of the image, all the while leaving the original RAW picture data unchanged.

Reflector. (1) Same as fill card. (2) A housing on a light that reflects the light outward in a controlled beam.

Rembrandt lighting. Same as 45-degree lighting.

RGB. Red, Green, and Blue. Computers and other digital devices handle color information as shades of red, green, and blue. A 24-bit digital camera, for example, will have 8 bits per channel in red, green, and blue, resulting in 256 shades of color per channel.

Rim lighting. Portrait lighting pattern where the key light is behind the subject and illuminates the edge of the subject. Most often used with profile poses.

Rule of thirds. Format for composition that divides the image area into thirds, horizontally and vertically. The intersection of two lines is a dynamic point where the subject should be placed for the most visual impact.

Scrim. A panel used to diffuse sunlight. Scrims can be set in windows, used on stands, or suspended in front of a light source to diffuse the light.

Sharpening. In Photoshop, filters that increase apparent sharpness by increasing the contrast of adjacent pixels within an image.

Short lighting. One of two basic types of portrait lighting in which the key light illuminates the side of the face turned away from the camera.

Slave. A remote-triggering device used to fire auxiliary flash units. These may be optical or radio-controlled.

Softbox. Same as a box light. Can contain one or more light heads and single or double-diffused scrims.

Split lighting. Type of portrait lighting that splits the face into two distinct areas: shadow side and highlight side. The key light is placed far to the side of the subject and slightly higher than the subject's head height. Also called cross lighting.

sRGB. Color matching standard jointly developed by Microsoft and Hewlett-Packard. Cameras, monitors, applications, and printers that comply with this standard are able to reproduce colors the same way. Also known as a color space designated for digital cameras.

Straight flash. The light of an on-camera flash unit that is used without diffusion; i.e., straight.

Subtractive fill-in. Lighting technique that uses a black card to subtract light from a subject area in order to create a better-defined lighting ratio. Also refers to the placement of a black card over the subject in outdoor portraiture to make the light more frontal and less overhead in nature.

TTL-balanced fill flash. Flash exposure systems that read the flash exposure through the camera lens and adjust flash output to compensate for flash and ambient light exposures, producing a balanced exposure.

Tension. A state of visual imbalance within a photograph. *See also* Balance.

TIFF (Tagged Image File Format). File format commonly used for image files. There are two kinds of TIFF files. The most popular TIFF file is the uncompressed type, meaning that no matter how many times a particular file is opened and closed, the data remains the same. There is also version

of the TIFF format that uses LZW compression, a lossless compression algorithm. However, it is not universally supported. All of the images that appear in this book were reproduced from uncompressed TIFF files.

Umbrella lighting. Type of soft, casual lighting that uses one or more photographic umbrellas to diffuse the light source(s).

Umbrellas, focusing. Adjusting the length of the exposed shaft of an umbrella in a light housing to optimize light output.

Unsharp Mask filter. Sharpening tool in Photoshop that locates pixels that differ from surrounding pixels and increases the pixels' contrast by amounts you specify. It is usually the last step in preparing an image for printing.

Vignette. A semicircular, soft-edged border around the main subject. Vignettes can be either light or dark in tone and can be included at the time of shooting, in printing, or produced with an image-editing program like Photoshop.

Watt-seconds. Numerical system used to rate the power output of electronic flash units. Primarily used to rate studio strobe systems.

White balance. The digital camera's ability to correct color and tint when shooting under different lighting conditions including daylight, indoor, and fluorescent lighting.

Wraparound lighting. Soft type of light, produced by umbrellas, that wraps around the subject, producing a low lighting ratio and open, well-illuminated highlight areas.

X sync. The shutter speed at which focal-plane shutters synchronize with electronic flash.

Zebra. A term used to describe photographic umbrellas having alternating reflecting materials such as silver and white cloth.

PORTRAIT PHOTOGRAPHER'S
HANDBOOK, 2nd Ed.
Bill Hurter

Bill Hurter has compiled a step-by-step guide to portraiture that easily leads the reader through all phases of portrait photography. This book will be an asset to experienced photographers and beginners alike. $29.95 list, 8½x11, 128p, 175 color photos, order no. 1708.

GROUP PORTRAIT
PHOTOGRAPHY HANDBOOK,
2nd Ed.
Bill Hurter

Featuring over 100 images by top photographers, this book offers practical techniques for composing, lighting, and posing group portraits—whether in the studio or on location. $34.95 list, 8½x11, 128p, 120 color photos, order no. 1740.

THE BEST OF CHILDREN'S
PORTRAIT PHOTOGRAPHY
Bill Hurter

Rangefinder editor Bill Hurter draws upon the experience and work of top professional photographers, uncovering the creative and technical skills they use to create their magical portraits of these young subejcts. $29.95 list, 8½x11, 128p, 150 color photos, order no. 1752.

THE BEST OF WEDDING
PHOTOJOURNALISM
Bill Hurter

Learn how top professionals capture these fleeting moments of laughter, tears, and romance. Features images from over twenty renowned wedding photographers. $29.95 list, 8½x11, 128p, 150 color photos, index, order no. 1774.

THE PORTRAIT PHOTOGRAPHER'S
GUIDE TO POSING
Bill Hurter

Posing can make or break an image. Now you can get the posing tips and techniques that have propelled the finest portrait photographers in the industry to the top. $29.95 list, 8½x11, 128p, 200 color photos, index, order no. 1779.

THE BEST OF
TEEN AND SENIOR
PORTRAIT PHOTOGRAPHY
Bill Hurter

Learn how top professionals create stunning images that capture the personality of their teen and senior subjects. $29.95 list, 8½x11, 128p, 150 color photos, index, order no. 1766.

THE BEST OF
PORTRAIT PHOTOGRAPHY
Bill Hurter

View outstanding images from top professionals and learn how they create their masterful images. Includes techniques for classic and contemporary portraits. $29.95 list, 8½x11, 128p, 200 color photos, index, order no. 1760.

THE BEST OF WEDDING
PHOTOGRAPHY, 2nd Ed.
Bill Hurter

Learn how the top wedding photographers in the industry transform special moments into lasting romantic treasures with the posing, lighting, album design, and customer service pointers found in this book. $34.95 list, 8½x11, 128p, 150 color photos, order no. 1747.

THE BEST OF DIGITAL
WEDDING PHOTOGRAPHY
Bill Hurter

Explore the groundbreaking images and techniques that are shaping the future of wedding photography. Includes dazzling photos from over 35 top photographers. $29.95 list, 8½x11, 128p, 175 color photos, index, order no. 1793.

THE BEST OF
PHOTOGRAPHIC LIGHTING
Bill Hurter

Top professionals reveal the secrets behind their successful strategies for studio, location, and outdoor lighting. Packed with tips for portraits, still lifes, and more. $34.95 list, 8½x11, 128p, 150 color photos, index, order no. 1808.

CORRECTIVE LIGHTING, POSING & RETOUCHING FOR
DIGITAL PORTRAIT PHOTOGRAPHERS, 2nd Ed.

Jeff Smith

Learn to make every client look his or her best by using lighting and posing to conceal real or imagined flaws—from baldness, to acne, to figure flaws. $34.95 list, 8½x11, 120p, 150 color photos, order no. 1711.

BEGINNER'S GUIDE TO ADOBE® PHOTOSHOP®, 2nd Ed.

Michelle Perkins

Learn to effectively make your images look their best, create original artwork, or add unique effects to any image. Topics are presented in short, easy-to-digest sections that will boost confidence and ensure outstanding images. $29.95 list, 8½x11, 128p, 300 color images, order no. 1732.

MARKETING & SELLING TECHNIQUES

FOR DIGITAL PORTRAIT PHOTOGRAPHERS

Kathleen Hawkins

Great portraits aren't enough to ensure the success of your business! Learn how to attract clients and boost your sales. $34.95 list, 8½x11, 128p, 150 color photos, index, order no. 1804.

ARTISTIC TECHNIQUES WITH ADOBE® PHOTOSHOP® AND COREL® PAINTER®

Deborah Lynn Ferro

Flex your creative skills and learn how to transform photographs into fine-art masterpieces. Step-by-step techniques make it easy! $34.95 list, 8½x11, 128p, 200 color images, index, order no. 1806.

DIGITAL PHOTOGRAPHY BOOT CAMP

Kevin Kubota

Kevin Kubota's popular workshop is now a book! A down-and-dirty, step-by-step course in building a professional photography workflow and creating digital images that sell! $34.95 list, 8½x11, 128p, 250 color images, index, order no. 1809.

PROFESSIONAL POSING TECHNIQUES FOR WEDDING AND

PORTRAIT PHOTOGRAPHERS

Norman Phillips

Master the techniques you need to pose subjects successfully—whether you are working with men, women, children, or groups. $34.95 list, 8½x11, 128p, 260 color photos, index, order no. 1810.

HOW TO START AND OPERATE A
DIGITAL PORTRAIT PHOTOGRAPHY STUDIO

Lou Jacobs Jr.

Learn how to build a successful digital portrait photography business—or breathe new life into an existing studio. $39.95 list, 6x9, 224p, 150 color images, index, order no. 1811.

NIGHT AND LOW-LIGHT

TECHNIQUES FOR DIGITAL PHOTOGRAPHY

Peter Cope

With even simple point-and-shoot digital cameras, you can create dazzling nighttime photos. Get started quickly with this step-by-step guide. $34.95 list, 8½x11, 128p, 100 color photos, index, order no. 1814.

PROFESSIONAL MARKETING & SELLING TECHNIQUES

FOR DIGITAL WEDDING PHOTOGRAPHERS,
SECOND EDITION

Kathleen Hawkins

Taking great photos isn't enough to ensure success! Become a master marketer and salesperson with these easy techniques. $34.95 list, 8½x11, 128p, 150 color photos, index, order no. 1815.